More

PROMOTION

ROCKPORT PUBLISHERS
GLOUCESTER, MASSACHUSETTS

First published in the United States of America by:
Rockport Publishers, Inc.
33 Commercial Street
Gloucester, Massachusetts 01930-5089
Telephone: (978) 282-9590
Facsimile: (978) 283-2742

Distributed to the book trade and art trade in the United States by:
North Light Books, an imprint of
F & W Publications
1507 Dana Avenue
Cincinnati, Ohio 45207
Telephone: (800) 289-0963

Other Distribution by:
Rockport Publishers, Inc.
Gloucester, Massachusetts 01930-5089

ISBN 1-56496-542-2

10 9 8 7 6 5 4 3 2 1

Layout: SYP Design & Production
Cover Image Credits (clockwise from top left: page 41,
page 37, page 57, page 22 , page 47, page 21

Manufactured in China

Introduction

No one denies the importance of promotion in any consumer-oriented company. Good promotion will bring in the money, bad promotion will hurt profits. The promotional materials collected in this volume each serve a different purpose, from event promotions to product promotions to direct response promotions. The style and approach of your promotional piece is entirely personal. You must evaluate what you hope to accomplish with the promotion as well as what image you plan to portray. A sophisticated brochure will entice potential customers with a mix of images and text. A playful, eye-catching T-shirt will serve as a walking, street-level billboard. A classy bag made of beautiful handmade paper will advertise the quality and the care of the store whose name it bears. A clever direct-mail piece will encourage the replies of the recipient and add a sense of wit to a company's image.

With so many choices, the possibilities are endless. By collecting different promotion programs in the same volume, you can compare and contrast the efficacy of different methods and approaches, and therefore choose the best and most appropriate program for you and your company. The outstanding designs collected here were created by top-level designers, and should prove to be inspirational for every client and designer.

Design Firm **Erbe Design**
Art Director/Designer
Maureen Erbe
Photography **Henry Blackham**
Copywriter **Erbe Design**
Client **Race Ready**
Tools **QuarkXPress**
Paper **Jefferson 80 lb. matte**

This brochure was designed as a direct-mail catalog for a company that sells running clothes. The concept was to sell the clothes by selling the image of the company. Interesting copy and photography establish the clothes as useful to the serious amateur athlete.

Design Firm **9Volt Visuals**
Art Director/Designer **Bobby June**
Photographer **Jason Nadeau**
Client **Pound Clothing**
Tools **Adobe Photoshop, Adobe Illustrator**
Paper **Chipboard**

Created strictly for promotional use, high-end models were made to look like they were wearing the client's clothing. The piece was produced on a tight budget and a chipboard cover was used to complete the effect.

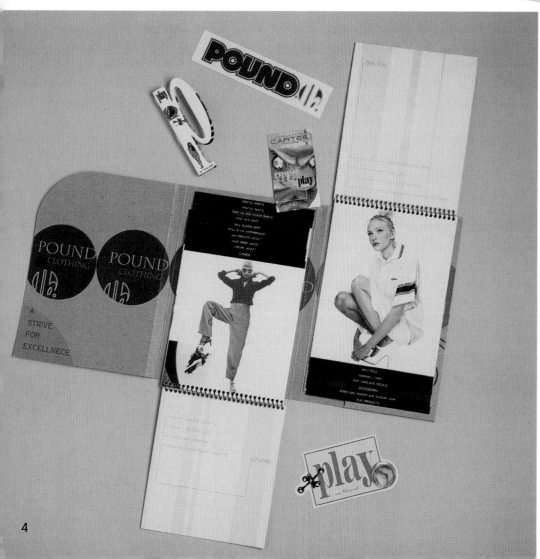

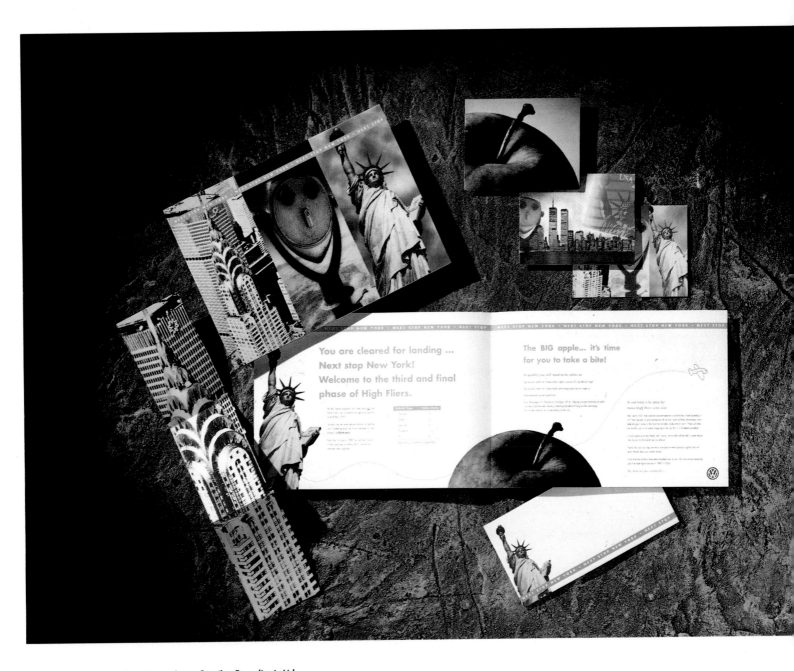

Design Firm **Acorn Creative Consultants Ltd.**
Art Director/Designer **Vanessa Dina-Barlow**
Client **Capital Incentives Ltd.**
Purpose or Occasion **VW incentives**
Paper/Printing **Silk-screen**
Number of Colors **Two**

This brief promoted a trip to New York City for qualified VW dealers. Using only two colors, the design reflected the "Big Apple" using striking duotone images and a graphic ticker-tape band. The pack consisted of a two-fold teaser, an informative brochure, and three follow-up postcards.

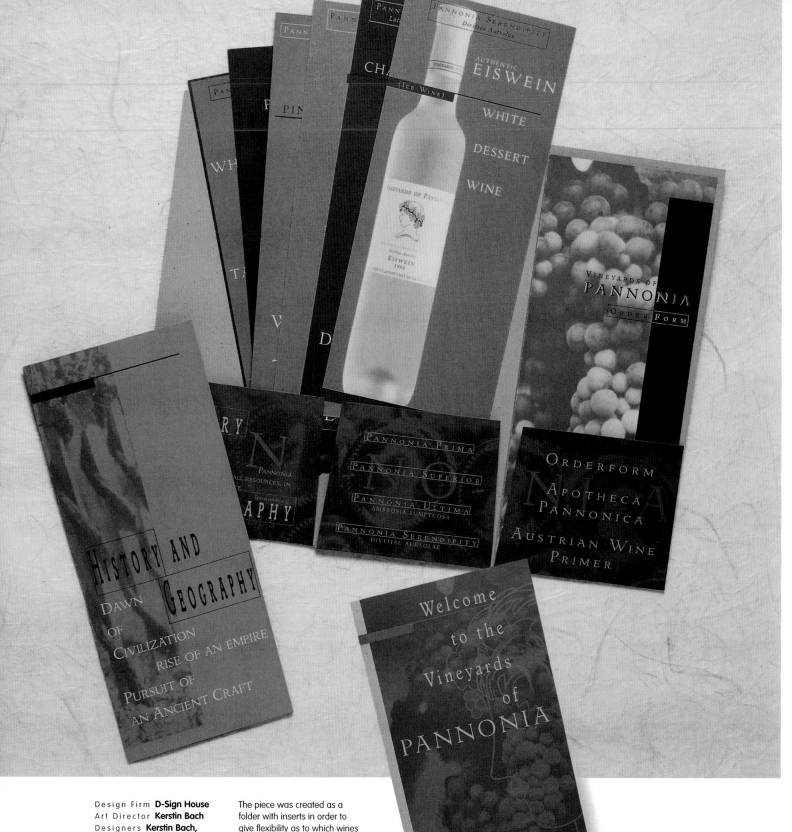

Design Firm **D-Sign House**
Art Director **Kerstin Bach**
Designers **Kerstin Bach,**
Sue Hoffman
Photos **Nattelie Scheurre**
Client **Pannonia Wines**
Tools **Macintosh,QuarkXPress,**
Adobe Photoshop,
Adobe Illustrator
Paper/Printing **Champion**
Carnival/Two-color offset

The piece was created as a
folder with inserts in order to
give flexibility as to which wines
are to be showcased or are
available. Also, the separated
pieces allowed a great range of
colors while keeping each piece
to two colors.

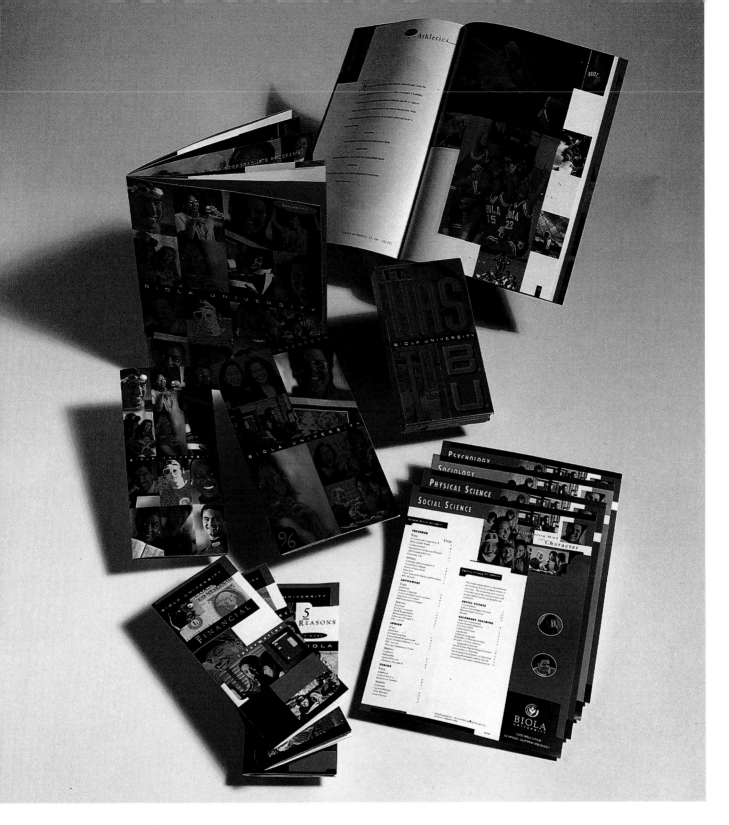

Design Firm **David Riley + Associates**
Art Director **David Riley**
Designers **Dwayne Cugdilli, Dennis Thorp, David Ferrell**
Photographer **Lonnie Duka**
Client **Biola University**
Purpose or Occasion **Recruitment collateral**

For over a decade, DR+A has been instrumental in helping Biola University define its corporate identity. Each piece of collateral is designed to build upon and complement the others. This marketing campaign was to highlight the school's sense of community and, as a result, position Biola's students and faculty as its greatest resource.

Design Firm
Robert Bailey Incorporated
Art Director/Designer
Dan Franklin
Illustrator
Katie Doka
Copywriter
Michael Hoye
Client
Flavorland Foods, Inc.
Tools
QuarkXPress,
Adobe Photoshop
Paper/Printing
Simpson Evergreen Birch/
Irwin-Hudson

The purpose of this brochure
was to promote the virtues of frozen
fruit first and Flavorland second.
It was meant to display in a rack as
well as hang like a poster.

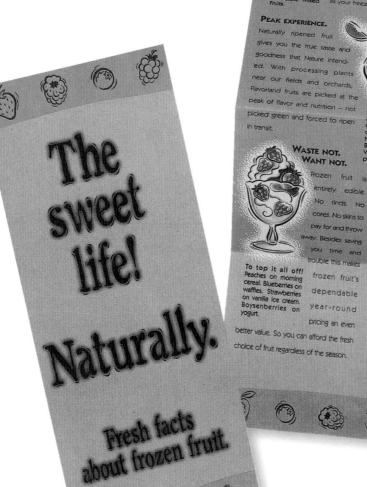

Frozen fruit: fast and healthy, wild and wise!

AROUND AND AROUND WE GO.

Around the clock and around the calendar, Flavorland frozen fruits can give your family all the nutritional benefits of a 100% natural food. Regardless of the time of day, regardless of the weather or the season, the all natural goodness of fruit is as handy as your freezer.

Be a good mixer! Chill out with a fruit salad. Or heat things up with a tasty compote. All you need is a bag of Berry Bonanza or Deluxe Mixed Fruits.

PEAK EXPERIENCE.

Naturally ripened fruit gives you the true taste and goodness that Nature intended. With processing plants near our fields and orchards, Flavorland fruits are picked at the peak of flavor and nutrition — not picked green and forced to ripen in transit.

WASTE NOT. WANT NOT.

Frozen fruit is entirely edible. No rinds. No cores. No skins to pay for and throw away. Besides saving you time and trouble this makes frozen fruit's dependable year-round pricing an even better value. So you can afford the fresh choice of fruit regardless of the season.

To top it all off! Peaches on morning cereal. Blueberries on waffles. Strawberries on vanilla ice cream. Boysenberries on yogurt.

THE SECRET OF BEING WELL PRESERVED.

We don't need sugar to make our fruit flavorful. At Flavorland we flash-freeze each berry or piece of fruit individually. When you thaw our frozen fruits, you get the color, taste and texture of hand-picked fruits and berries. Not a frozen mass of fruit and syrup.

A FEW HOT TIPS.

Buy frozen fruits the last thing before checking out and unpack them first when you get home. Before you buy, check each package for clumping. Fruits and berries should flow freely. Clumping means that the fruit has thawed after processing and re-frozen. For maximum freshness set your freezer to 0° F or lower and check it periodically with a freezer thermometer.

TAKE THE EASY WAY OUT.

Everybody wants good nutrition, but who has time to do all the work? Let Flavorland do it for you. Versatile frozen fruits are cleaned and ready to use right out of the bag. Fruit makes an easy and wholesome alternative to fat-laden snack foods.

Guilt free snack! Skip the chips. Try a grape or a slice of peach right out of the bag. No fat. No added salt. But loaded with Vitamin C. They're positively virtuous.

IT TAKES ALL KINDS.

Variety of foods is a key to good nutrition as well as the spice of life. Nutritional experts recommend 2 to 4 helpings of fruit every day. The wide variety of Flavorland frozen fruits makes it easy and economical to please your family and get them the good nutrition they need.

Your finger in every pie! How about cherry, blueberry, a banana and boysenberry for openers? Then maybe raspberry or peach? And for the finale? Strawberry-rhubarb, of course!

Let them eat cake! And have them begging for more. Raspberries bring out the royalty in a chocolate cake. Dark sweet cherries make a princely Jubilee!

UNLEASH THE POWER OF THE PYRAMID.

The USDA puts the 5 major food groups in a pyramid that shows how much and how often they should be eaten for optimal nutrition. Fruit is a foundation player in good health. It gives you plenty of vitamins and fiber without fat or added sugar. Frozen fruits are a wholesome and fun alternative to high fat snacks and desserts.

Shake it up! Mix frozen fruit, yogurt, a banana and milk or juice in your blender for a sensational smoothie. For a rich shake, add a scoop of ice cream.

THE FOOD GUIDE PYRAMID.

Use Sparingly
Fats, Oils and Sweets

2-3 Servings Daily
Milk, Yogurt and Cheese Group

2-3 Servings Daily
Meat, Poultry, Fish, Dry Beans, Eggs and Nuts Group

2-4 Servings Daily
Vegetable Group

2-4 Servings Daily
Fruit Group

6-11 Servings Daily
Bread, Cereal, Rice and Pasta Group

The sweet life! Naturally.

FLAVOR LAND

The sweet life! Naturally.

Fresh facts about frozen fruit.

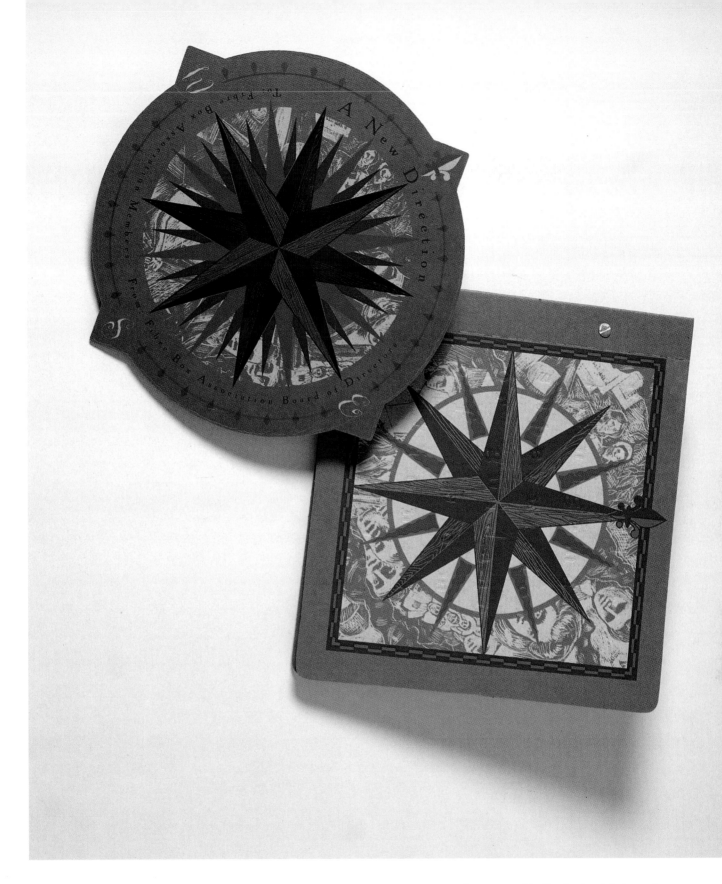

Design Firm **Love Packaging Group**
Art Director **Tracy Holdeman**
Designer/Illustrator **Chris West**
Client **Fibre Box Association**
Purpose or Occasion **FBA Annual Meeting**
Paper/Printing **Corrugated/Graphic Products (silk-screen printing)**
Number of Colors **Four**

Increasing awareness and participation of the Fibre Box Association's annual meeting was the main focus of this pair of business-to-business teaser/mailer and program pieces. The compass graphics and type were all produced with Macromedia FreeHand with the custom scratchboard illustrations scanned in Adobe Photoshop. Both the compass teaser and the program were silk-screened and spot varnished. The corrugated program cover has a special blind debossed typographic treatment. Program cover, liner sheets, and pages were all hand assembled with aluminum screw posts.

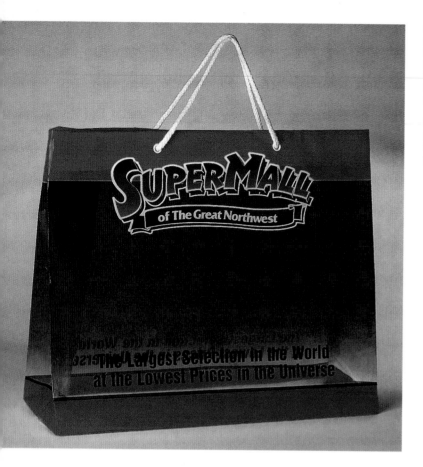

Design Firm **Morris Beecher**
Art Director **Diane Beecher**
Designer **Catherine Nunn**
Illustrator **Catherine Nunn**
Client/Store **SuperMall of The Great Northwest**
Bag Manufacturer **Kal Pac**
Paper/Printing **Plastic; rotogravure**

The client required that the art mesh with existing designs in other media, from billboards to brochures. For security reasons, the design had to work on a partially transparent bag.

Design Firm **Mike Salisbury Communications**
Art Director **Mike Salisbury**
Designer **Mike Salisbury**
Illustrator **Mary Evelyn McGough**
Photographer **Mike Salisbury**
Client/Store **The Village**
Paper/Printing **4-color offset**

First, the designer used Adobe Photoshop to manipulate the photograph of the building and combine it with other L.A. scenery (palm trees, blue skies, motorcycles, etc.), conveying the right attitude for the state-of-the-art recording studio. He re-collaged the computer-composite image by hand to take it one step further.

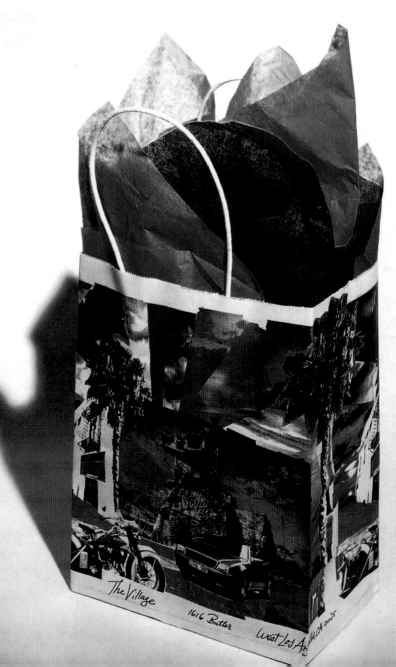

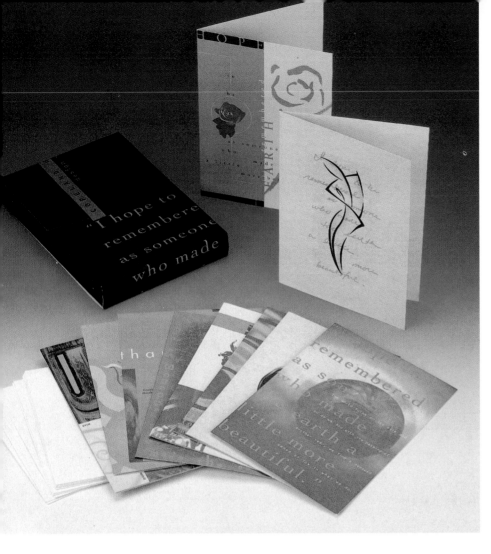

Design Firm
Copeland Hirthler design and communications
Creative Directors
Brad Copeland, George Hirthler
Art Directors
David Butler, Raquel C. Miqueli
Designers
David Butler, Lea Nichols, David Woodward, David Crawford, Shawn Brasfield, Todd Brooks, Sean Goss, Jeff Hack, Sam Hero, Sarah Huie, Mark Ligameri, Raquel Miqueli, David Park, Melanie Bass Pollard, Michelle Stirna, Mike Weikert
Illustrators
Studio
Client
Copeland Hirthler design and communications
Purpose or Occasion
Seasonal promotion
Paper/Printing
Neenah
Number of Colors
Four

This seasonal gift/promotion incorporates twelve different interpretations of a card with a message that centers on peace.

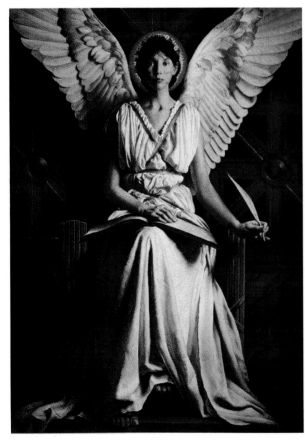

Design Firm
Bartels and Company
Art Director
David Bartels
Designer
John Postelwait
Illustrators
Michael Deas, Gregory Manchess, Gary Kelley, Robert Rodriguez, Ted Coconis, Guy Porfirio
Client
St. Patrick Center
Purpose or Occasion
Fund-raising
Paper/Printing
Quest Printing
Number of Colors
Four plus varnish

The cards were the inspiration of a staff member at the St. Patrick Center. Design services for the project were donated and illustrators were solicited to render the necessary graphics. The illustrators were paid a token fee and the printing and paper were billed at cost.

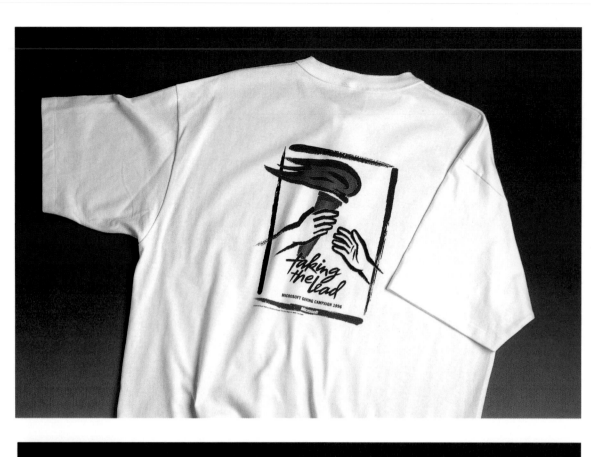

Design Firm
Tim Girvin Design, Inc.
Art Director/Designer
Tim Girvin
Illustrator
Tim Girvin, Gretchen Wegner
Client
Microsoft Corporation
Purpose or Occasion
Giving campaign
Number of Colors
Four

The design goal was to create a distinctly non-digital feel with something in what was characterized as a more hand-done, art-driven, signature stylistic direction. This was celebrated as a powerful and refreshing departure from promotions that had focused more on direct computer-generated imagery.

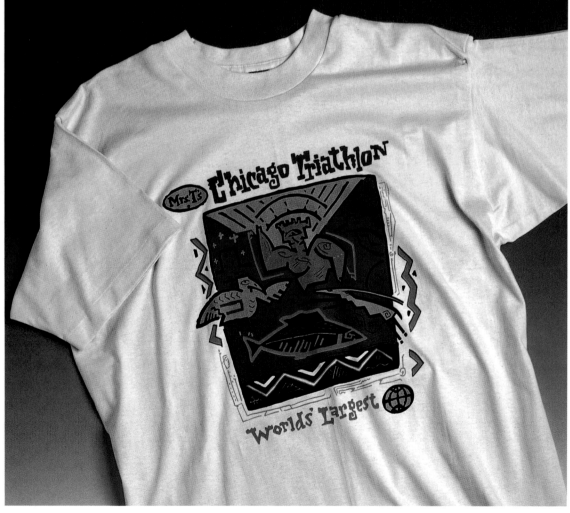

Design Firm
Jim Lange Design
Art Director
Jan Caille
Designer/Illustrator
Jim Lange
Client
Mrs. T's Pierogies
Purpose or Occasion
Chicago triathlon
Number of Colors
Four

Here the triathlete is a timeless man, a primal force as old as the antelope and fish in the sea, with the same universal primitive energies and action to life. The designer wanted to capture something as old as time—man as nature.

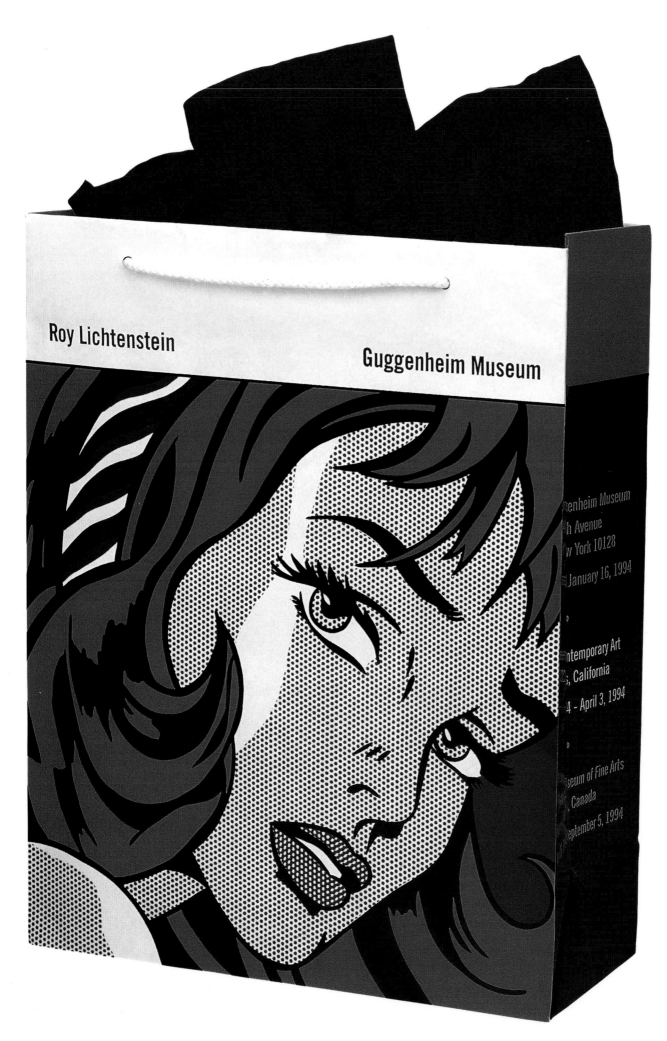

Roy Lichtenstein

Guggenheim Museum

...enheim Museum
...h Avenue
...w York 10128
... January 16, 1994

...ntemporary Art
..., California
...4 - April 3, 1994

...seum of Fine Arts
..., Canada
...eptember 5, 1994

Design Firm
Greenberg-Kingsley
Designer
Roy Lichtenstein
Client/Store
**Guggenheim Museum,
Roy Lichtenstein**
Bag Manufacturer
**Keenpac North America
Ltd.**
Distributor
Metro Packaging Group

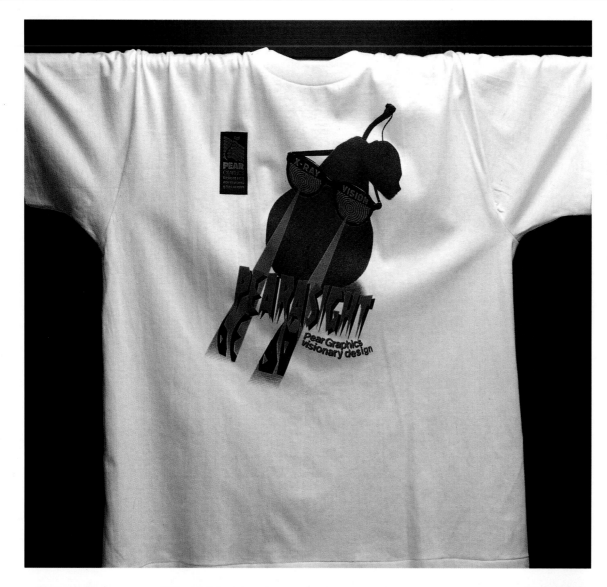

Design Firm
Pear Graphics Inc.
All Design
Kim Farnham
Purpose or Occasion
Quarterly newsletter mailing give away
Number of Colors
Four

The design was done in a Freehand with various Photoshop TIFFs. The pear image was first placed in Freehand, printed black and white with a large screen pattern, and then rescanned and manipulated.

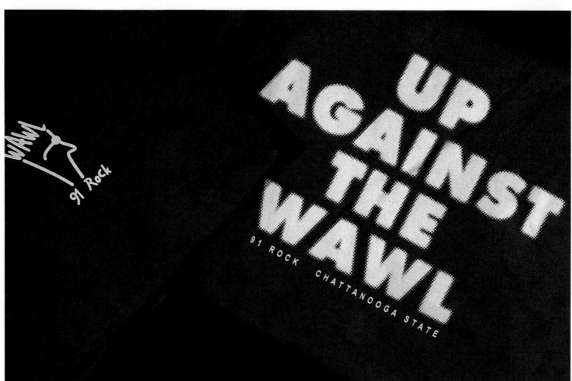

Design Firm
Chattanooga State Tech Community College
Art Director
Lisa Wright
Designer/Illustrator
Heidi Cawood
Client
College's Radio Station WAWL 91 Rock
Purpose or Occasion
For trivia give aways
Number of Colors
One

The college's radio station is very popular with the high-school crowd. They wanted to make a logo T-shirt that would be coveted by high school students.

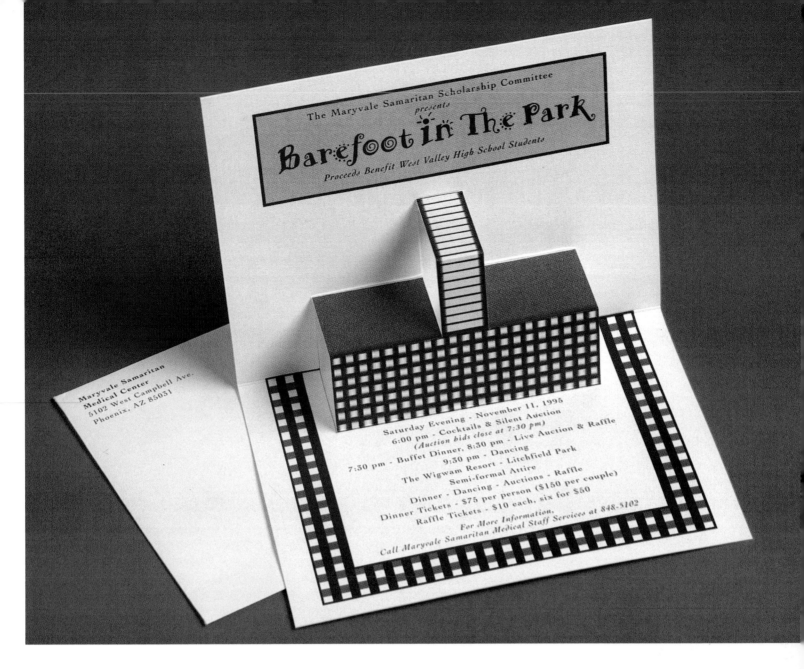

Design Firm **Samaritan Design Center**
Art Director **Al Luna**
Designers **Al Luna, Louis Giordano**
Illustrator **Louis Giordano**
Client **Maryvale Samaritan Scholarship Committee**
Purpose or Occasion **Scholarship fund-raiser**
Paper/Printing **Classic linen**
Number of Color **Three**

The client requested something fun to accompany the picnic theme. A three-dimensional picnic basket with a pop-up feature adds interest for the recipient. The basket was created in Adobe Photoshop, printed, and die-cut. Other elements included large picnic baskets as center pieces and checkered tablecloths.

15

Design Firm **Design Center**
Art Director **John Reger**
Designer **Sherwin Schwartzrock**
Copywriter **John Roberg**
Client **Spanlink**
Tools **Macintosh, Macromedia FreeHand**
Paper/Printing **Warren Lustro, Olympic Printers**

Using a light presentation with whimsical graphics, the piece's purpose is to show a problem with telephones and the solution. A special graphic is placed in die-cut form on the first page.

Still puzzling over the age-old call center problems?

Understaffing

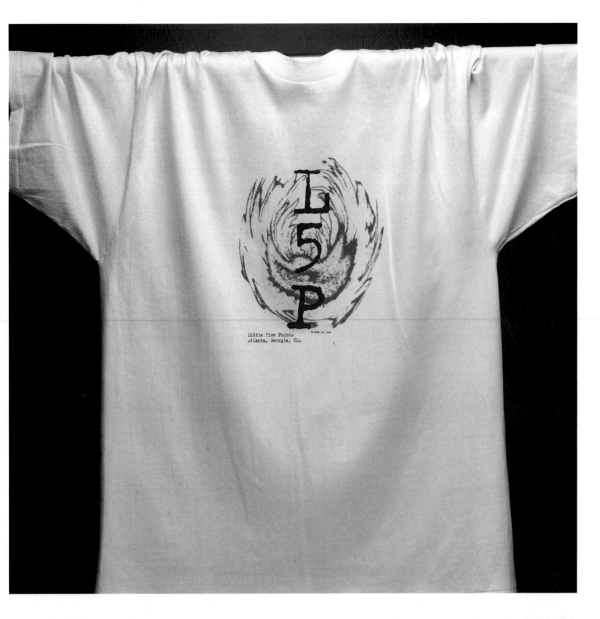

Design Firm
Fuse
Art Director
Pete Rundquist
Designer/Illustrator
Joanna Duryea
Purpose or Occasion
To heighten familiarity of L5P
Number of Colors
Two

This T-shirt was created with the intention of capturing a psychedelic seventies feeling. L5P is the commonly used short name for Little Five Points, a diverse community in Atlanta where this design studio is located.

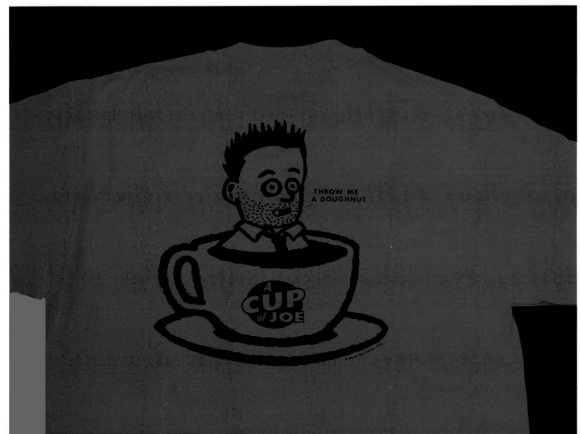

Design Firm
Sandy Gin Design
Designer/Illustrator
Sandy Gin
Purpose or Occasion
Self-promotion
Number of Colors
One

This T-shirt, created to promote the design studio, emphasizes fun and wackiness. A lot of people on the street stop to ask "Who is that guy? He looks like he needs a shave!"

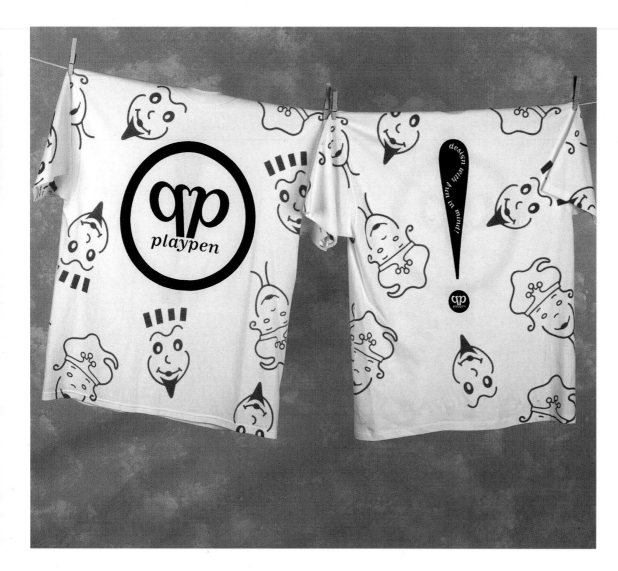

Design Firm
Playpen
Art Director
Natalie Kirschner, David Byrnes
Designer
Toni Jannelli
Purpose or Occasion
Promotional give away
Number of Colors
Two

The design strategy was to make a break from the average white T-shirt. The designer used an overall print that allowed her to add the silly boy and girl "heads" while maintaining the clean strong logo of the playpen, front and center. Bold, playful, clean, and fun was the goal—and it had to complement the firm's print package.

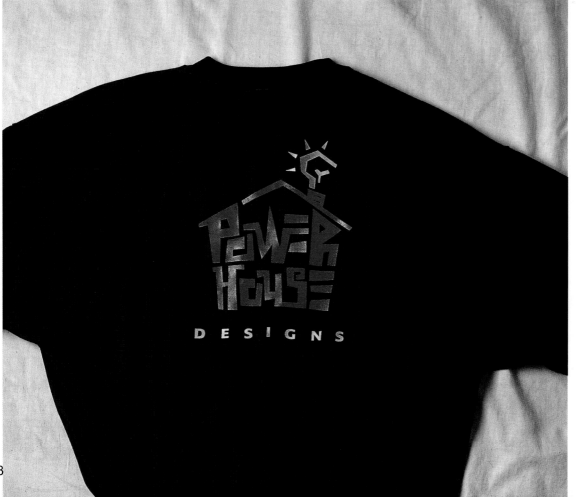

Design Firm
Powerhouse Designs
Designer
Nancy Terasawa, Ellie Choi
Purpose or Occasion
Self-promotion
Number of Colors
Two

The shirt was designed as a part of a self-promotional package that would be given to clients. It includes the Powerhouse design logo, which was created in Adobe Illustrator. Powerhouse Designs is a freelance design business that started a year ago. This shirt was designed in hopes of helping to visually advertise the business.

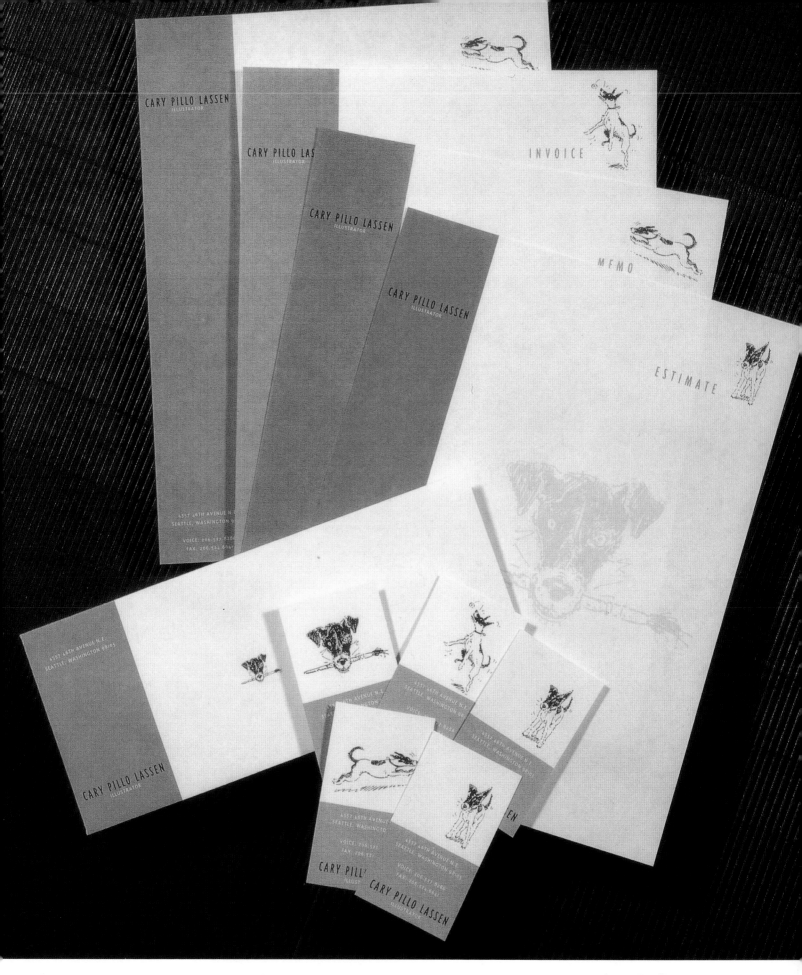

INVOICE

MEMO

ESTIMATE

CARY PILLO LASSEN
ILLUSTRATOR

Design Firm **Belyea Design Alliance**
Art Director **Patricia Belyea**
Designer **Tim Ruszel**
Illustrator **Cary Pillo Lassen**
Client **Cary Pillo Lassen**

Design Firm
BIG Bugs Inc.
Art Director
Peter Amft
Photographer
Des Barttlet
Illustrator
Tim McClelland
Client
PBS
Purpose or Occasion
Promotion for TV nature film
Number of Colors
One

The photo was murky and gray, so Tim McClelland helped by putting it into a "dither" program on his Mac and shifting the values around.

Design Firm
BIG Bugs Inc.
Art Director/Designer
Peter Amft
Photographer
Peter Amft
Client
Alligator Records
Purpose or Occasion
Twentieth anniversary promotion
Number of Colors
One

T-shirt printers always want to use a coarse 50 or 65 line screen, but the designer put this through a 133 line mezzo screen, and it worked fine.

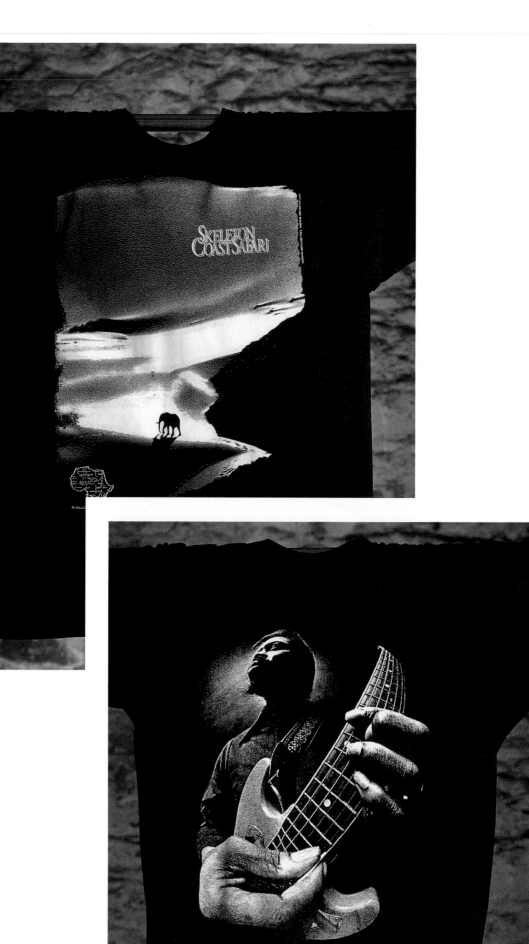

20

c a t a l o g
of Media Resources

DesignFirm
Design Center
Art Director
John Reger
Designer
John Erickson
Copywriter
Church Metro
Client
Church Metro
Tools
Macintosh, Macromedia FreeHand
Paper/Printing
Lustro/Printcraft

To entice the viewer to take a look inside, the designers used text (representing books) and earphones (for tapes). The goal was to take a serious subject and make it fun.

Books

Becoming a Woman of Excellence

Cynthia Heald

In this motivating Bible study, married and single women can discover what they should be striving for with God's excellence as a model. If you're hungry for God's perspective on success in a society that bombards you with conflicting demands, feed on the truths of God's Word that you'll discover in this book. You will not only learn to "approve the things that are excellent," but you will experience the joy of becoming God's woman of excellence.
Order Code: HEABWEB
Price: $7.00

Life Launch: A Passionate Guide to the Rest of Your Life

Frederic M. Hudson & Pamela D. McLean

Are you better off today, at being who you are, than you were a year ago? At work? At home? There are not many blueprints or safety nets guiding our lives in our now familiar world of constant surprises. You have to create your own turbulent world, our lives and careers must be redesigned over and over again as we live them. Few know how to do this, as they shift gears in the endless churning of complex change. Life Launch provides the tools you need to author your future, no matter what your age and situation. You will learn to facilitate optimal choices within your own vision and reach — weaving together personal and professional plans around your deep sense of purpose.
Order Code: HUDLLPB
Price: $16.95

The Case for Christianity

C.S. Lewis

This is Lewis at his best. He presents the case for Christian belief in two parts, "Right and Wrong as a Clue to the Meaning of the Universe" and "What Christians Believe." With all the power of his formidable intellect and his legendary style, C.S. Lewis condenses the arguments for the reasonableness of Christian faith in an admirable, concise, and compelling presentation.
Order Code: LEWCFCB
Price: $5.95

The Seven Habits of Highly Effective People

Stephen R. Covey

This book has been a national bestseller for several years, with more than 30 million copies in print. Now available in 17 languages and 20 countries, this enlightening book teaches how to get more fulfillment from your time; your own life. You will learn the inside-out approach to personal effectiveness.
Order Code: COVSHHB
Price: $14.00

Leadership is an Art

Max DePree

Max DePree's form of leadership is based on the human values of care and concern. His "wisdom" book teaches how to enrich the sense of personal achievement that is sorely missing in today's workplace. "CEO Max DePree grabs the gold. This book is thoughtful, personal human, persuasive." – Tom Peters.
Order Code: DEPLAB
Price: $13.00

Leadership Jazz

Max DePree

Max DePree examines excellence in business. By comparing leadership and jazz, DePree shows how a leader can find his or her unique voice while incorporating such conflicting ingredients as freedom and technique, improvisation and rules, inspiration and restraint.
Order Code: DEPLJB
Price: $13.00

Design Firm
Dean Johnson Design
Art Director
John Hill
Designer/Illustrator
Bruce Dean
Client
Broad Ripple Brew Pub
Purpose or Occasion
Sales
Number of Colors
Four

This was produced for a neighborhood
microbrewery from a pastel drawing
and iron-on. Quick turnaround and
easy reprints made this shirt design
readily available. Sales continue
to be extremely strong.

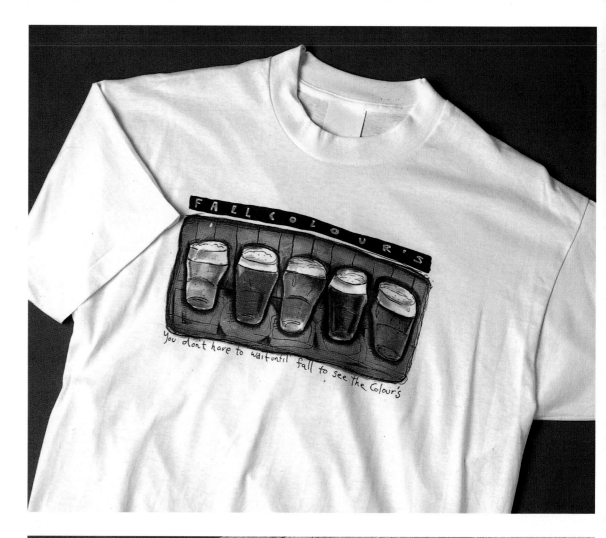

Design Firm
Dean Johnson Design
Designer/Illustrator
Bruce Dean
Client
Broad Ripple Brew Pub
Purpose or Occasion
Sales
Number of Colors
Four

A neighborhood microbrewery sells a line of
screen printed shirts. This was produced
from a pastel drawing and ironed-on. Quick
turnaround and easy reprints made this shirt
design readily available. Sales continue to
be extremely strong.

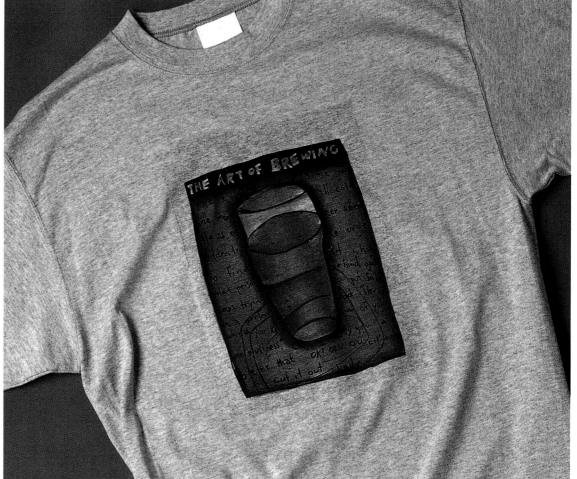

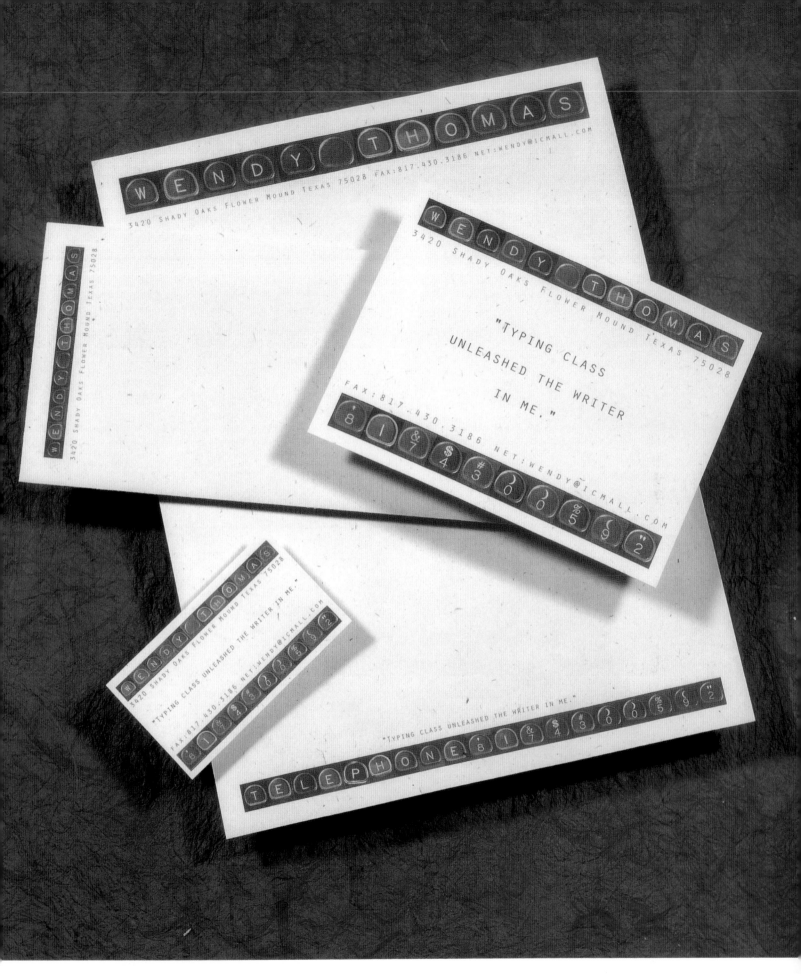

Design Firm **Elena Design**
Art Director/Designer **Elena Baca**
Illustrator **Phototone Alphabets**
Client **Wendy Thomas**
Tools **QuarkXPress**
Paper/Printing **French Speckeltone**

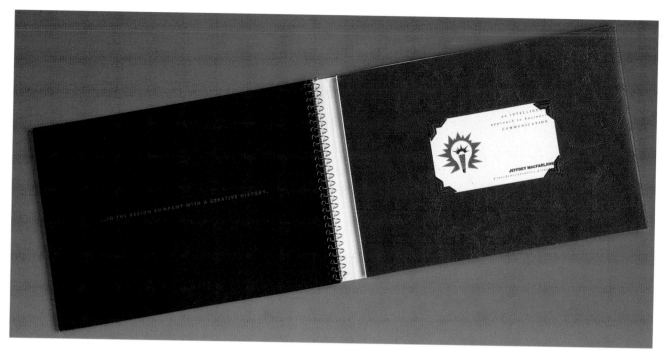

Design Firm
Get Smart Design Company
Art Director
Jeff Macfarlane
Designer
Tom Culbertson
Client
Get Smart Design Company
Purpose or Occasion
Moving announcement
Paper/Printing
Union-Hoermann Press, Johnson Graphics
Number of Colors
Three

The purpose of the piece was to announce the company's relocation by including the reason for the move as part of the graphic effect. The concept was to take what may be a very ordinary event and transform it into something special and funny. The leatherette binding was used to add a keepsake value to the piece.

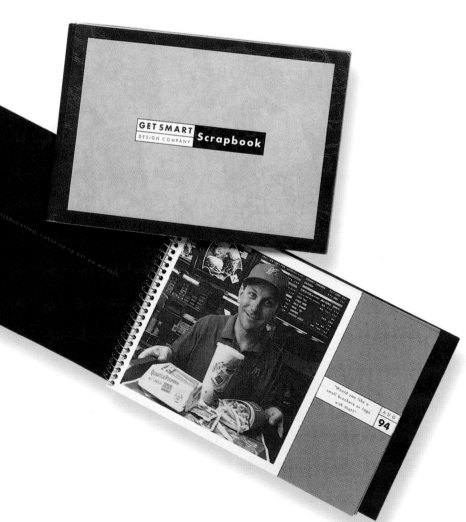

Design Firm
Tandem Graphics
Art Director/
Designer
Caren Schindelwick
Illustrator
David Weeks
Client
Tandem Graphics
Purpose or Occasion
Christmas card
Number of Colors
Four

This combination Christmas card and puzzle was personalized with a handwritten greeting on the back. The recipient was confronted with an envelope full of pieces, and the greeting was readable only after solving the puzzle.

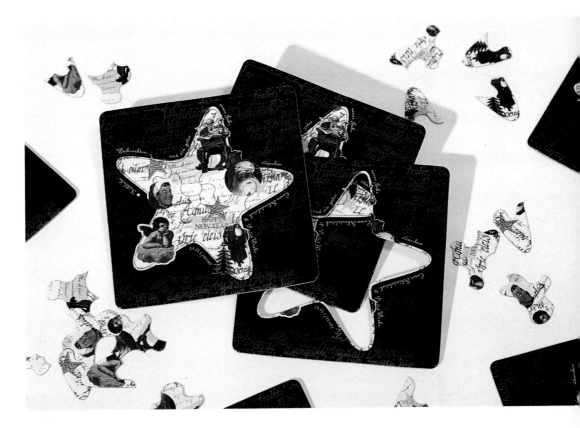

Design Firm
Tandem Graphics
Art Director/Designer
Caren Schindelwick
Illustrator
David Weeks
Client
Tandem Graphics
Purpose or Occasion
Christmas card
Paper
Proxiedelmatt
Number of Colors
Four

Hanging from a balloon, Santa Claus floats into the picture and then disappears with a surprised expression on his face when the balloon suddenly deflates. After developing the Santa character, the flip-back story board was animated in Infini-D, and prepared for print using Adobe Photoshop and Illustrator. The finished book was hand bound and mailed in a custom-designed envelope.

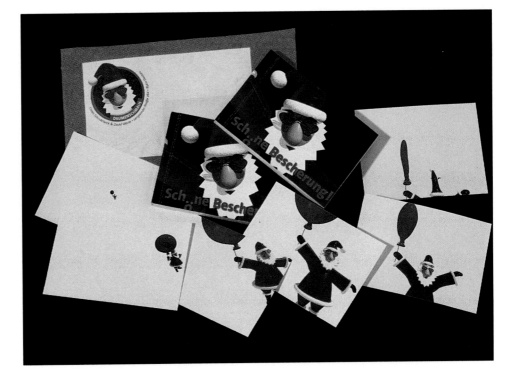

Design Firm
McGaughy Design
Art Director/
Designer
Malcolm McGaughy
Client
McGaughy Design
Purpose or Occasion
Holiday greeting
Paper/Printing
Laser paper/Laser printer
Number of Colors
Three

For an unexpected look, the designer ran out the cards on a Laserwriter, cut and ripped them by hand, and then applied color with a highlighter.

Design Firm
Sagmeister, Inc.
Art Director
Stefan Sagmeister
Designer
Veronica Oh
Client
Aerosmith
Purpose or Occasion
Christmas card
Paper/Printing
100 lb. cover
Number of Colors
One

This postcard utilizes a flexo disc and includes a regular pin attached to cardboard. When the disc is turned by hand, the cardboard serves as a loudspeaker and the card becomes a working record player. Aerosmith recorded a Christmas song especially for this card.

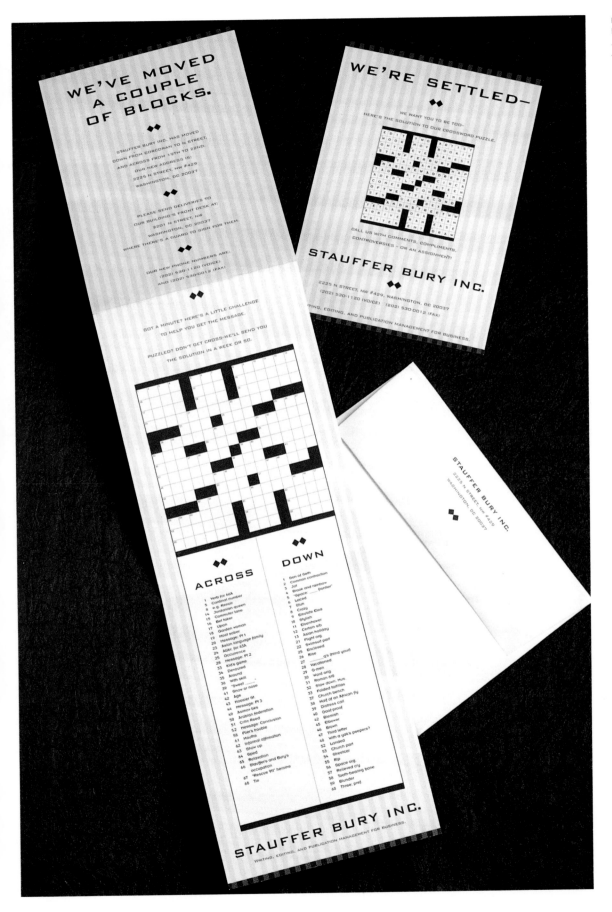

Design Firm
Franz and Company, Inc.
Art Directors
Jean Franz, Steve Trapero
Designer
Steve Trapero
Client
Stauffer Bury, Inc.
Purpose or Occasion
Moving announcement and pro-motion
Paper/Printing
Navajo cover, ultra white
Number of Colors
Two

A husband-and-wife writing team were moving down and across town, only a few blocks away, thus the idea for a crossword puzzle with an encrypted message hidden within the answers. The answer was sent about a week after the initial mailing.

27

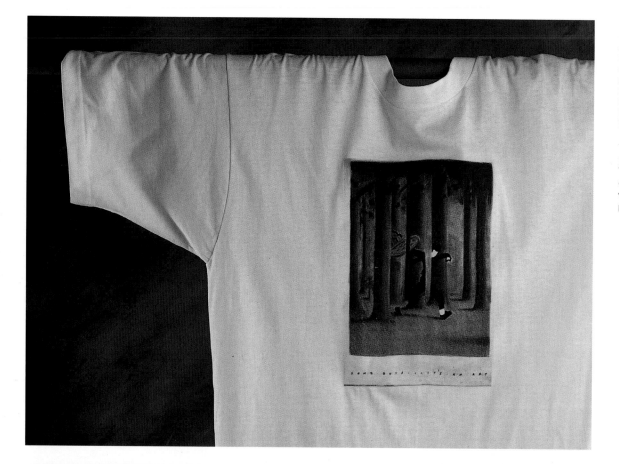

Design Firm
Dean Johnson Design
All Design
Bruce Dean
Client
Some Guys Pizza
Purpose or Occasion
Restaurant promotion
Number of Colors
Four

This shirt is one in a series of works that promote a specialty pizza restaurant. The artwork in each case is a take-off of a well-known artist so that viewers will associate artwork with the art of pizza preparation.

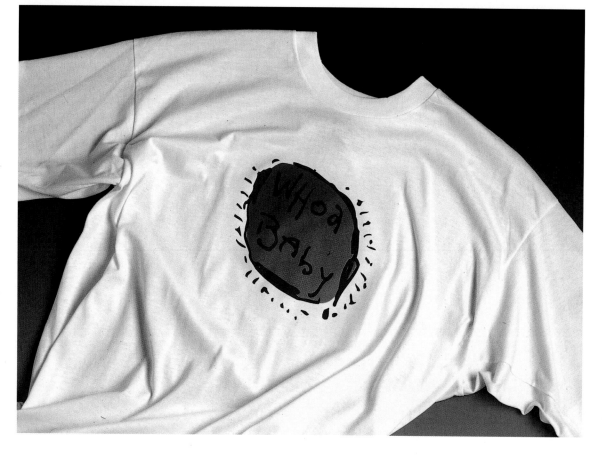

Design Firm
Dean Johnson Design
Art Director
Charlie Dean
Designer/Illustrator
Bruce Dean
Client
Some Guys Pizza
Purpose or Occasion
Restaurant promotion
Number of Colors
Four

This is one in a series of shirt designs that are also paintings inside the restaurant. All shirts have sold well and have helped build a creative image and personal connection with the restaurant's customers.

Design Firm **Cornoyer-Hedrick, Inc.**
All Design **Lanie Gotcher**
Copywriter **Mary Baldwin**
Client **Williams Gateway Airport**
Tools **QuarkXPress, Adobe Illustrator**
Paper **Quintessa 100 lb. dull; Folder/brochure/
dividers: Classic Crest 70 lb.**

Designed to transform from a pocket folder to a proposal by trimming pieces and wirebinding, this piece picks up airport runway elements and includes a custom pocket folder with information sheets and a proposal book.

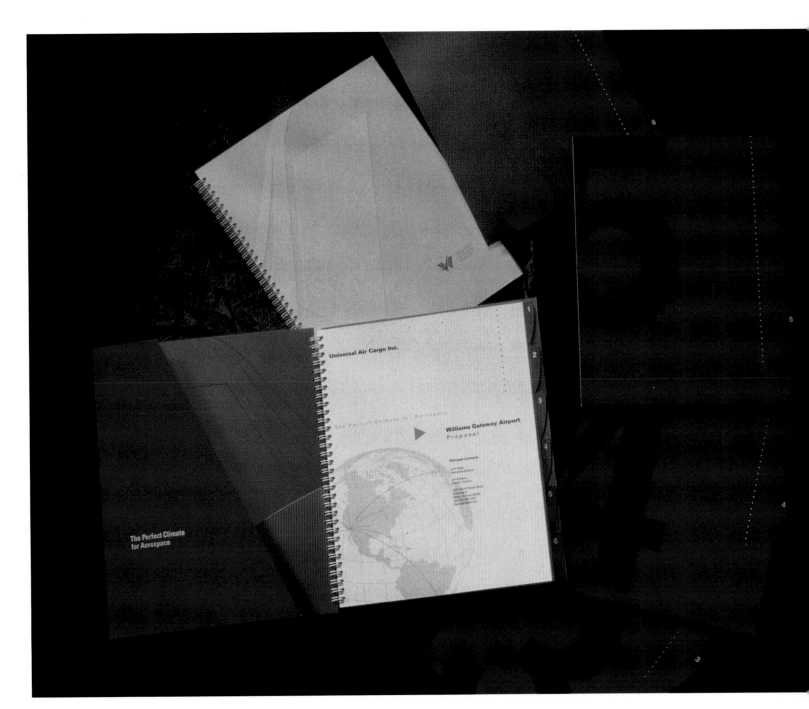

Mathematica art images generated by simple programs based on two-dimensional colored noise (all by [?]akshee).

Design Firm **Wolfram Research Creative Services**
Art Director **John Bonadies**
Designers **John Bonadies, Jody Jasinski**
Illustrator **Michael Trott**
Copywriter **Stephen Wolfram**
Client **Wolfram Research, Inc.**
Tools **Mathematica, Adobe Illustrator, Adobe Photoshop, QuarkXPress**
Paper **Warren 70 lb. dull**

This brochure's purpose is to communicate, in a manner that is comprehensive as well as easily understood, the features and extensive functionality of Mathematica 3.0, a fully integrated technical computing software package.

WOLFRAM RESEARCH

A First Look At MATHEMATICA® 3.0

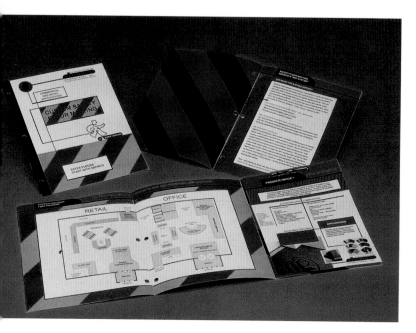

Design Firm
Sayles Graphic Design
All Design
John Sayles
Copywriter
Wendy Lyons
Client
Sbemco International
Paper/Printing
Springhill/Offset printing

As part of an ongoing identity campaign, the piece features the Step Ahead theme. The piece includes the use of the company's trademarked fuchsia and teal backing. Designed to be flexible, the catalog has a metal fastener which attaches individual pages with details on specific product lines.

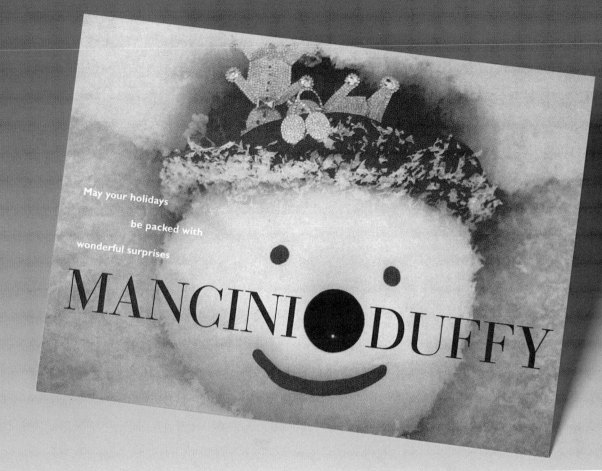

May your holidays be packed with wonderful surprises

MANCINI DUFFY

Design Firm
Toni Schowalter Design
Art Director/
Designer
Toni Schowalter
Client
Mancini Duffy
Purpose or Occasion
Holiday greeting
Paper/Printing
Strathmore 28 lb. ultimate white card
Number of Colors
Two

Using inexpensive two-color printing, the color photo was brought into Adobe Photoshop to isolate the nose. The card plays off the interior design firm's logo that incorporates a holiday motif in the snowman.

Art Director
Simon Mould
Illustrator
James Marsh
Client
Nemo Cards
Purpose or Occasion
Christmas card
Number of Colors
Four

This four-color Christmas card was designed to appeal to frog lovers.

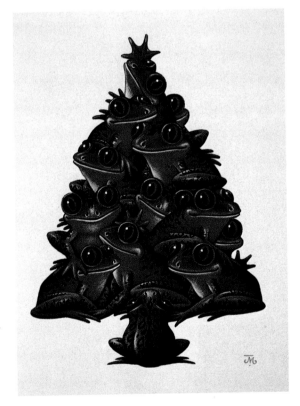

Event

Design Firm
Love Packaging Group
Art Director
Brian Miller
Designer/Illustrator
Chris West
Project
FBA direct mail
Client
Fibre Box Association
Purpose or Occasion
Annual meeting
Software
Macromedia FreeHand,
Adobe Photoshop
Hardware
Power Computing Power Tower
Pro 225

This teaser/mailer establishes
the graphic vocabulary used in all
subsequent pieces in the series. The
puzzle piece that detaches from the
corrugated portion is taken to the event
and redeemed for the meeting program.
The puzzle piece fits into an identical
die-cut in the program's cover.

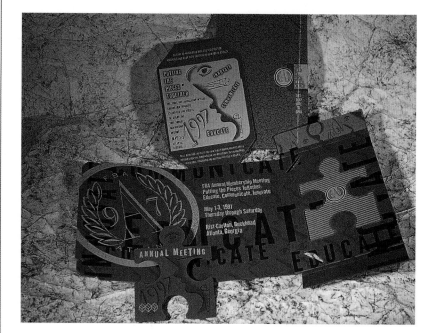

Event

Design Firm
Mirko Ilić Corporation
Art Director/Designer
Mirko Ilić
Project
Poster for lecture
Client
Syracuse University
Purpose or Occasion
Lecture announcement
Software
Adobe Photoshop, Adobe Illustrator
Hardware
Macintosh 8500

Since the lecture was mostly about
computer-generated design and
illustration, artwork already used
for other purposes was included in
the piece.

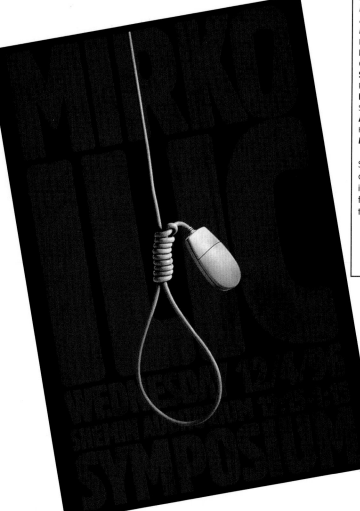

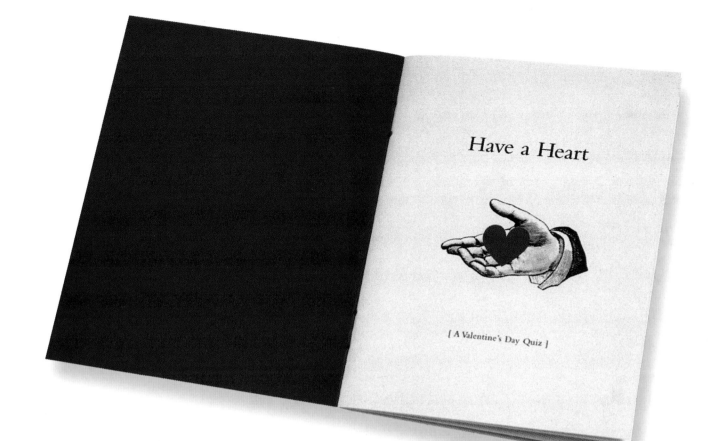

Have a Heart

[A Valentine's Day Quiz]

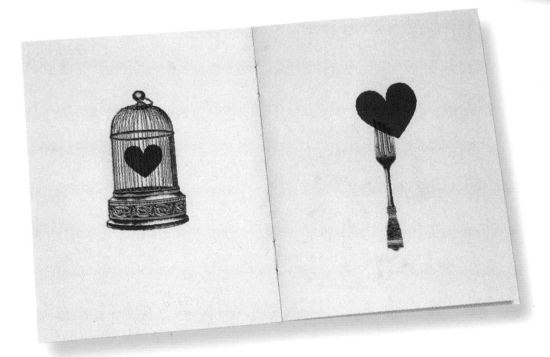

Design Firm
Toni Schowalter Design
Art Director/Designer
Toni Schowalter
Client
Toni Schowalter Design
Purpose or Occasion
Valentine's Day greeting
Paper/Printing
Neenah classic, Finch
Number of Colors
Two

Using scanned archive images and printing with hearts, the piece is a quiz that involves the viewer and creates visual metaphors of well-known sayings that include hearts.

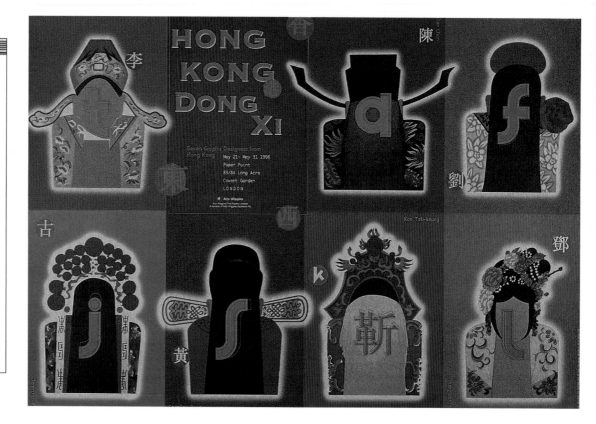

Design Firm
Kan and Lau Design Consultants
Art Director
Freeman Lau Siu Hong
Designers
Freeman Lau Siu Hong, Joseph Leung
Computer Illustrator
John Tam Mo Fai
Project
Hong Kong Dong Xi—exhibition poster
Client
Wiggins Teape (Hong Kong), Ltd.
Purpose or Occasion
Design exhibition
Software
Adobe Photoshop, Macromedia FreeHand
Hardware
Power Macintosh

This piece was designed to announce the Hong Kong designers exhibition in London.

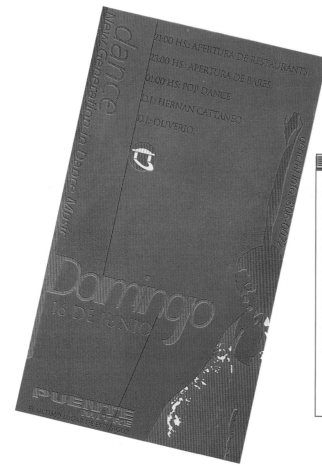

Design Firm
Cato Berro Diseño
Art Director
Gonzalo Berro
Designers
Gonzalo Berro, Esteban Serrano
Project
Domingo
Client
Puente Mitre
Purpose or Occasion
Party
Software
Adobe Illustrator
Hardware
Macintosh 7200/90

Design Firm
Siebert Design Associates
Art Director/Designer
Lori Siebert
Illustrators
Juliette Borda, Lon Siebert, Lisa Ballard
Copywriters
Joe Lewis II, Joe Lewis III
Client
Contemporary Arts Center
Printing
Westerman Printing

Cincinnati's Contemporary Arts Center sponsors an outreach program in which a visiting artist goes to inner-city schools and gives a presentation. The children are given this book that is so special in its design they wouldn't dream of throwing it away.

Design Firm
Mires Design
Art Director
Scott Mires
Designer
Scott Mires, Deborah Hom
Illustrator
Tracy Sabin
Client
Harcourt Brace & Co.
Purpose or Occasion
Promotion
Number of Colors
Four

The T-shirt was created to commemorate the completion of a year-long project—a series of educational textbooks for children. The T-shirt was a gift to everyone who was involved with the project as a way of saying, "We made a great team, thank you for your hard work."

Design Firm
Mires Design
Art Director
Scott Mires
Designer
Eric Freedman
Illustrator
Steven Guarnaccia
Client
Food Group
Purpose or Occasion
Promotion
Number of Colors
Four

The Summertime Sweepstakes T-shirt was intended to be a promotional gift to Calavo avocado distributors. The photograph of an avocado in an illustrated scene was part of the campaign imagery. The avocado is high diving into a vat of guacamole, while tortilla chips look on.

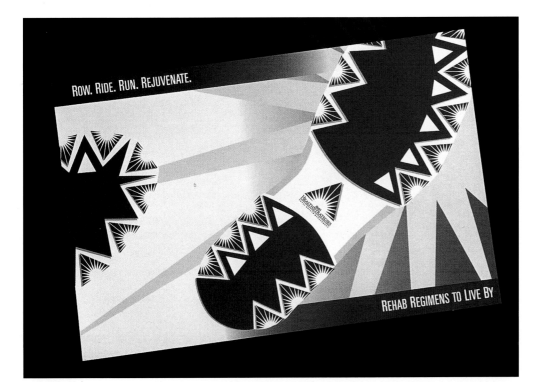

ROW. RIDE. RUN. REJUVENATE.

REHAB REGIMENS TO LIVE BY

Promotion

Design Firm
Held Diedrich
Art Director
Doug Diedrich
Designer/Illustrator
Jeff Wiggington
Project
Direct-mail series
Client
BMH Health Strategies
Purpose or Occasion
Direct-mail campaign
Software
Adobe Illustrator, Adobe Photoshop, QuarkXPress
Hardware
Macintosh 7600 Power PC

This direct-mail campaign was targeted at a variety of audiences. Thematically, the piece was intended to maintain a connection to previous print materials that had been created. Illustrator was used to create the shoe-print image and photos were stock CD images that were converted through Photoshop to duotones. Final electronic files were created with QuarkXPress.

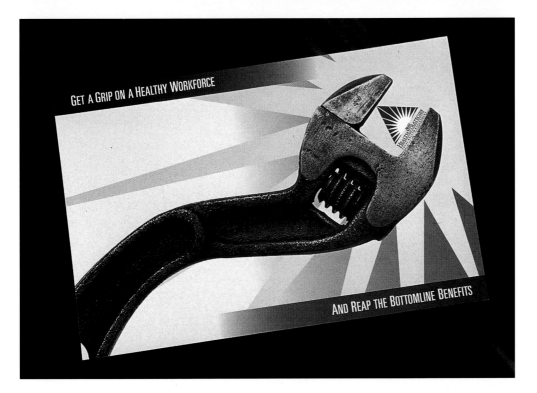

GET A GRIP ON A HEALTHY WORKFORCE

AND REAP THE BOTTOMLINE BENEFITS

Promotion

Design Firm
Held Diedrich
Art Director
Doug Diedrich
Designer/Illustrator
Jeff Wiggington
Project
Direct-mail series
Client
BMH Health Strategies
Purpose or Occasion
Direct-mail campaign
Software
Adobe Illustrator, Adobe Photoshop, QuarkXPress
Hardware
Macintosh 7600 Power PC

This direct-mail campaign was targeted at a variety of audiences. Thematically, the piece was intended to maintain a connection to previous print materials that had been created.

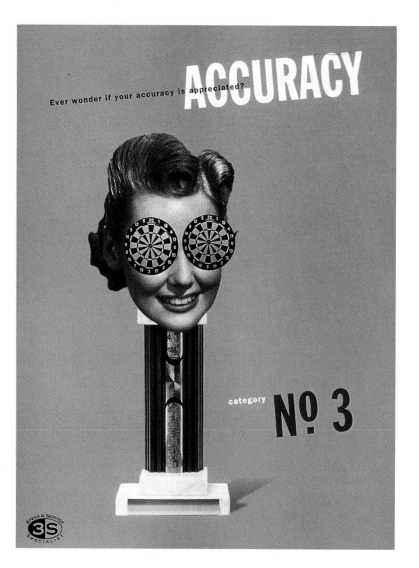

ACCURACY

Ever wonder if your accuracy is appreciated?

category Nº 3

Event

Design Firm
Design Guys
Art Director
Steven Sikora
Designer
Richard Boynton
Project
Target cashier triathlon posters
Client
Target
Purpose or Occasion
Promoting improved cashier performance
Software
Adobe Photoshop, Adobe Illustrator, QuarkXPress
Hardware
Macintosh Quadra 950

The Target cashier triathlon was a speed-and-service program for store cashiers. The series of six posters comprised three teaser posters before the program's introduction and three monthly reminder posters after the program's launch.

Event

Design Firm
McCullough Creative Group
All Design
Mike Schmalz
Project
Poster
Client
Dubuque Main Street
Purpose or Occasion
Outdoor concert series
Software
Adobe Photoshop
Hardware
Power Macintosh 8500/150

This illustration was created to promote a non-profit outdoor summer jazz concert series. The illustration was first sketched and scanned to use as a template when rendering the final illustration in Adobe Photoshop.

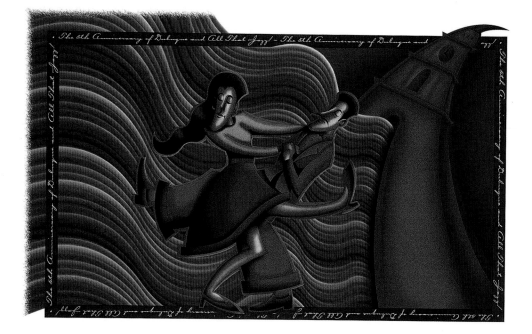

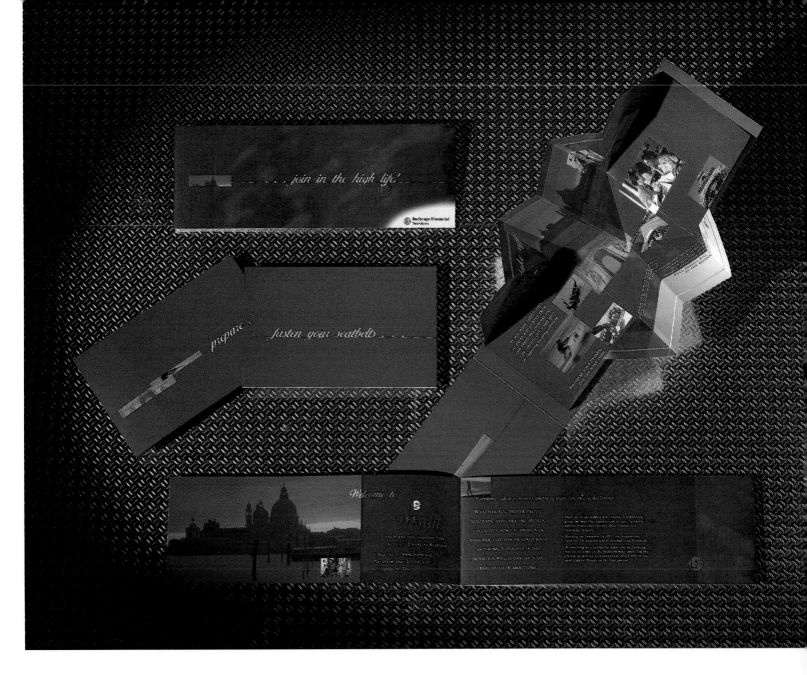

Design Firm **Acorn Creative Consultants Ltd.**
Art Director/Designer **Simon Reason**
Illustrator **Image Bank**
Client **Capital Incentives Ltd.**
Purpose or Occasion **Promote new business insurance**
Paper/Printing **McNaughton Skygloss 300 gsm, 170 gsm**
Number of Colors **Four plus special**

The direct mail piece consisted of two parts: Part 1 was a teaser consisting of a slipcased landscape folder with minimal copy and close-up details of locations featured in the scheme. This opened to reveal a pop-up. Part 2 was a landscape booklet, revealing more detail of locations. KPT filters were used to create textures.

∇

Design Firm **Standard Deluxe, Inc.**
Art Director **Scott Peek**
Designers **Scott Peek, Chad Gray**
Client **Rotary Club of Loachapoka**
Purpose or Occasion **20th Anniversary keepsake**
Paper/Printing **Postcard/Hand silk-screened**
Number of Colors **Two front, one back**

"Syrup Soppin" Day in Loachapoka, Alabama is an annual event where crafts are displayed, syrup is made the old-fashioned way, bluegrass music is played, and there is plenty of barbecue and socializing. The image on the promotional cards was also used for T-shirts. The designers hand silk-screened these cards to give them a homey feel.

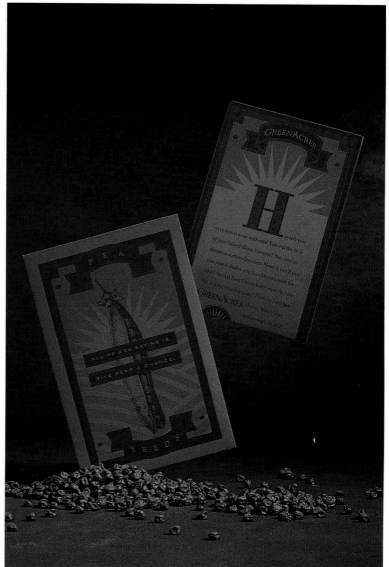

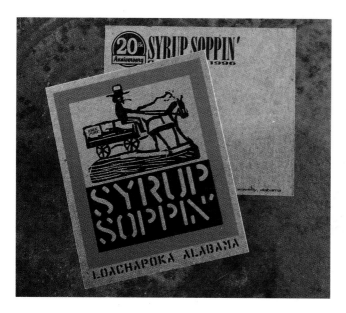

△

Design Firm **Greteman Group**
All Design **Sonia Greteman, James Strange**
Client **Green Acres**
Purpose or Occasion **Direct mail**
Paper/Printing **Manila paper/Offset**
Number of Colors **Two**

This direct-mail piece announces the grand opening and offers a 25% discount on particular items. All art was created in Macromedia FreeHand, and actual peas were included with the card and coupon. Manila paper and a manila envelope were used in printing.

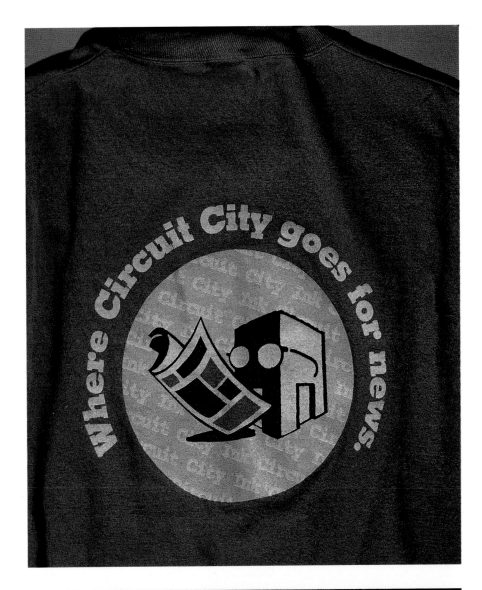

Design Firm
CommuniQué Marketing
Art Director/Designer
C. Benjamin Dacus
Illustrator
Joel Priddy
Client
Circuit City Stores
Purpose or Occasion
Thank-you for contributing to CIRCUIT CITY INK magazine
Number of Colors
Three

The goal of the designers was to generate interest in the employee magazine by giving T-shirts to individuals who contributed to the magazine in some way. The look ties in with the design and other material designed by the firm, including the magazine itself.

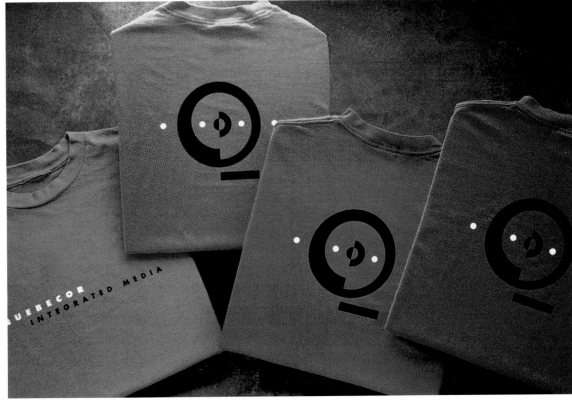

Design Firm
Hornall Anderson Design Works, Inc.
Art Director
Jack Anderson
Designer
Jack Anderson, Heidi Favour, Mary Hermes, Mary Chin Hutchison
Client
Quebecor Integrated Media
Purpose or Occasion
Promotional
Number of Colors
Two

The client needed a series of T-shirts that incorporated their new identity as a means of promotional use. The four colors reflected are the same ones seen throughout their stationery program and promotional marketing binders system.

Design Firm **HC Design**
Art Director **Chuck Sundin**
Designer/Illustrator **Steve Trapero**
Client **GCA—Graphic Communications Association**
Purpose or Occasion **Call for papers for European conference**
Paper/Printing **House stock gloss**
Number of Colors **Three PMS colors plus flood gloss varnish**

The client wanted to have a piece that reflected Europe through its colors and design. Since type and color were the predominant design elements, the type needed to be interesting to look at and yet still legible. The cover has an intentionally clean design, and poses a question that piques the recipient's curiosity about the contents. Adobe Illustrator and QuarkXPress were used.

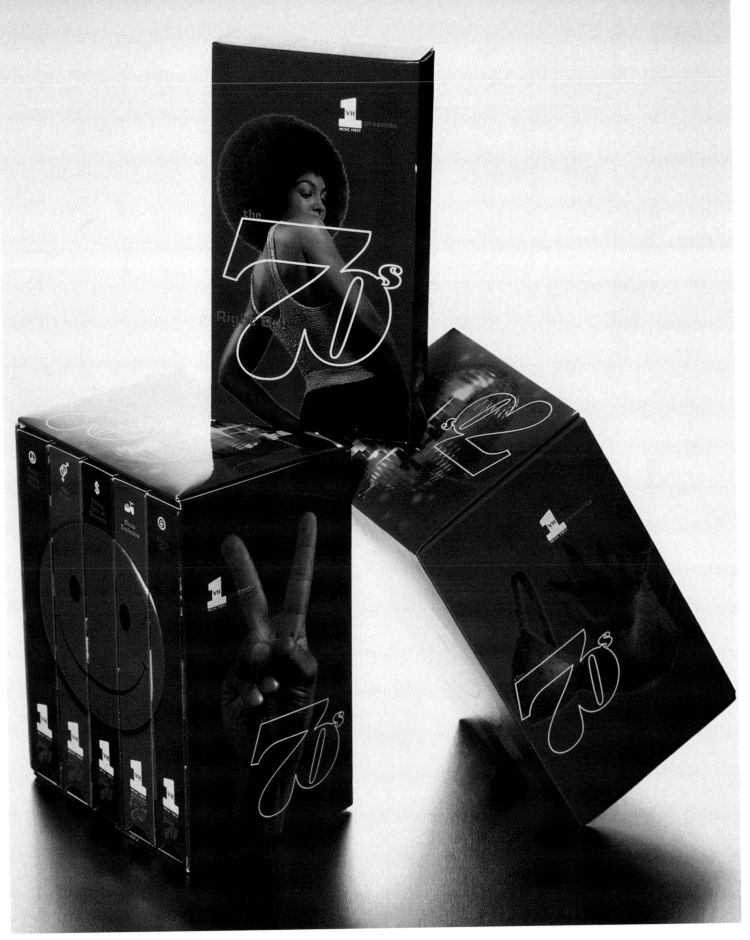

Design Firm **Parham Santana Inc.**
Art Director **Dean Lubensky, VH1**
Designer **Rick Tesoro, Paula Kelly**
Photographer **Peter Medilek**
Client **VH1**
Product **Videotapes**
Technique **Offset**

VH1 programming was packaged as a promotion to advertisers and affiliates. Icons of the era were conceived and photographed to represent a nineties retrospective of the seventies.

Let's Get This Show

Pop Wagner and

Stoney Lonesome

On The Road!

Design Firm **MartinRoss Design**
Designers **Martin Skoro, Ross Rezac**
Copywriter **Patricia McKernon**
Client **Pop Wagner and
Stoney Lonesome**
Tools **QuarkXPress**
Paper/Printing **Coated paper/
Four-color process**

Using existing photos, the client wanted a
brochure that would stand out from other
promotions. A die-cut was used to make
the distinction, and color, playful use of
type, and trimmed photos were used to
appeal to the people who booked shows.

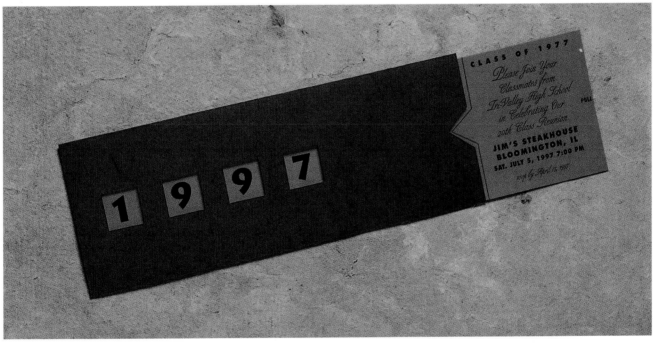

Design Firm **Tracy Griffin Sleeter**
Designer **Tracy Griffin Sleeter/Rocky**
Client **Tri-Valley High School Class of '77**
Purpose or Occasion **20th class reunion announcement**
Paper/Printing **Laser printing**
Number of Colors **One**

The class of 1977 had no class funds left from the previous reunion. With the limited quantity of sixty pieces, the designers could not justify offset or indigo printing. All invitations were hand-cut, laser printed, and glued. The time involved was six hours, and the total cost was $22.00 plus envelopes and postage.

Design Firm **Sibley/Peteet Design**
Art Director/Designer **Don Sibley**
Client **Weyerhaeuser Paper Company**

This series of brochures for Weyerhaeuser Paper Company promotes their Cougar Offset grade and is part of an ongoing "American Artifacts" campaign. The piece is geared toward graphic designers and printers, and focuses on innovative printing techniques.

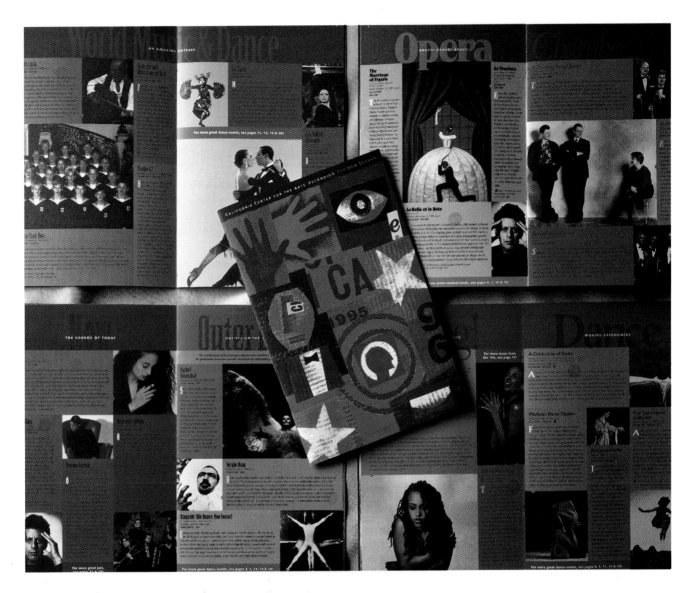

△
Design Firm **Mires Design**
Art Director **John Ball**
Designers **Kathy Carpentier-Moore, John Ball**
Illustrator **Gerald Bustamante**
Client **California Center for the Arts**
Paper/Printing **Nehoosa/Offset, Bordeaux Printers**
Number of Colors **Five**

This direct-mail brochure sells performing-arts season subscriptions.

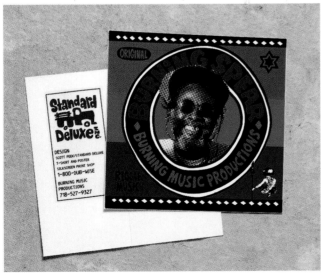

◁
Design Firm **Standard Deluxe, Inc.**
Art Director/Designer **Scott Peek**
Client **Burning Music Productions**
Purpose or Occasion **Promotional decal to sell on tour and in a retail merchandise catalog**
Number of Colors **Four plus clear coat**

The artwork was originally created for and screen-printed on T-shirts; all the type and separations were done by hand (mostly with amberlith film and an X-Acto knife). The designer wanted to create a "rootsy" feel to fit with the music.

Design Firm
Schwartz Design
Art Director/Designer
Bonnie Schwartz
Illustrator
Tracy Sabin
Project
Center for Executive Health brochure
Client
Scripps Memorial Hospital
Purpose or Occasion
Promotional brochure
Software
Adobe Illustrator
Hardware
Macintosh 9500

The illustration was created for
a brochure directed at business
executives that outlines the available
health-care services. A positive,
light-hearted approach to the graphics
was deemed appropriate.

Design Firm
Parham Santana, Inc.
Art Director
Elisa Feinman/USA Networks
Designers
John Parham, Dave Wang
Project
Grand Slam Tennis on USA
Client
USA Network
Purpose or Occasion
Sales/promotion kit
Software
**Adobe Photoshop, Adobe Illustrator,
QuarkXPress**
Hardware
Macintosh 8500

This is a sales/promotion kit for cable
rights to two grand-slam tennis events
on USA Network. The kit is characterized
by bold yet elegant style for program-
ming that targets an exclusive demo-
graphic. Player images were blurred and
silhouetted on metallic and color back-
grounds and a simulated foil stamp
embossing was achieved using Adobe
Photoshop.

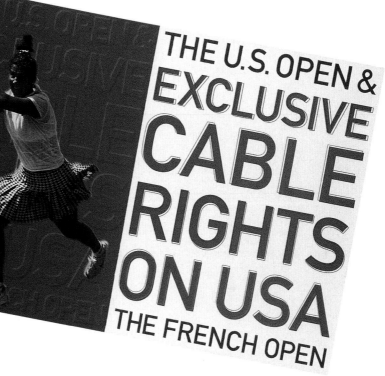

48

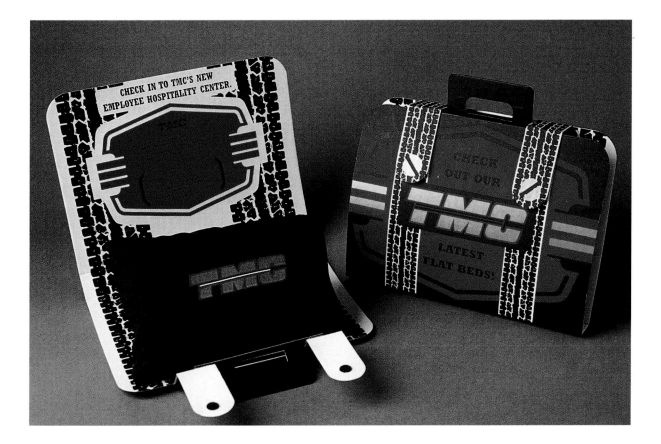

Design Firm **Sayles Graphic Design**
Art Director **John Sayles**
Designers **John Sayles, Jennifer Elliot**
Copywriter **Wendy Lyons**
Illustrator **John Sayles**
Client **TMC Transportation**
Purpose or Occasion **Grand-opening announcement**
Paper/Printing **Curtis Riblaid Black, corrugated/Screen-printed, laminated; Image Maker**
Number of Colors **Three**

The TMC Hospitality Center is a company-owned hotel with accommodations available only to the flatbed trucking line's employee-drivers. This unique announcement is a corrugated suitcase screen-printed with tire tracks; inside is a custom-made pillow embroidered with the company logo with a foil-wrapped TMC chocolate attached. Copy invites recipients to "take a closer look at our flatbeds," a reference to both the trucking company's equipment and the amenities of the new Hospitality Center.

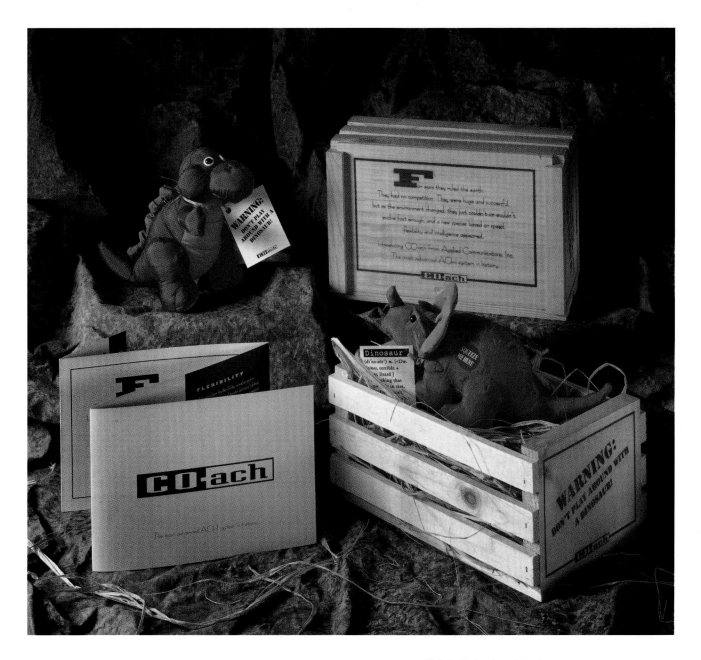

Design Firm **Webster Design Associates, Inc.**
Art Director **Dave Webster**
Designers **Dave Webster, Todd Eby**
Illustrator **Ryle Smith**
Client **ACI**
Purpose or Occasion **Introduce new product**
Paper or Printing **Nappa Wooden Box Company**
Number of Colors **One**

The slogan "Don't play around with a dinosaur" was an ideal way of saying that ACI's technology is faster and more efficient than their competitor's product. At the same time, the use of a squeaking toy dinosaur softens the hard edge of the message, making the point more palatable than a hard, straight sell.

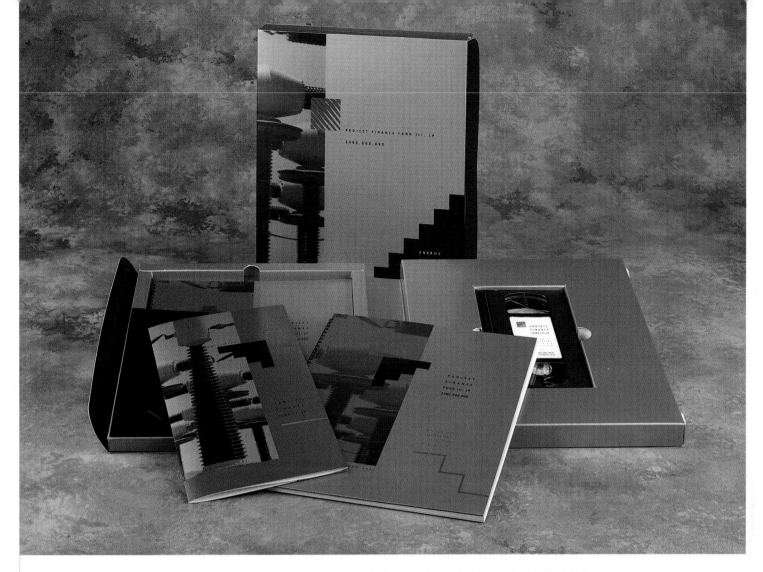

Design Firm **Washam Design**
Art Director/Designer **Thurlow Washam, Linda McKenzie**
Client **Energy Investors Funds Group**
Product **Collateral materials for a financial investment fund**
Technique **Offset, foil stamp**

The packaging needed to tie into the corporate and video look. By using video out takes and the corporate colors plus the logo, Washam Design was able to put together a package that housed all the support materials (prospectus, brochure, letter, business card, and video). The packaging was created in QuarkXPress and Adobe Illustrator.

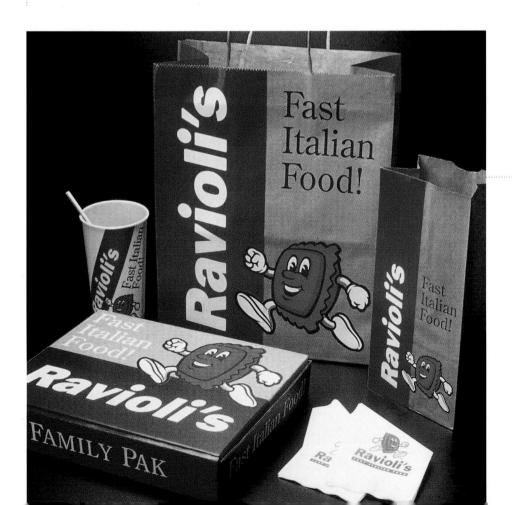

Design Firm **Curtis Design**
All Design **David Curtis**
Client **Florentine Restaurant**
Product **Fast-food identity system**

Curtis Design created a running cartoon mascot that serves as a metaphor for fast Italian food. The energetic "Ravioli-Man" was then incorporated into a restaurant concept promoting its all-natural pasta products as a healthy and fun alternative to fried foods.

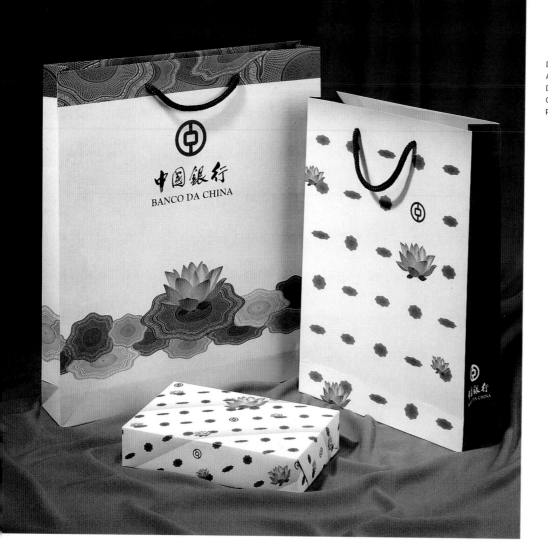

Design Firm **Kan Tai-keung Design & Associates Ltd.**
Art Director **Kan Tai-keung**
Designer **Veronica Cheung Lai Sheung**
Client/Store **Bank of China–Macau Branch**
Paper/Printing **C & C Offset Printing Co. Ltd.**

Design Firm **Kan Tai-keung Design & Associates Ltd.**
Art Director **Kan Tai-keung**
Designer **Joyce Ho Ngai Sing**
Client/Store **Bank of China–Hong Kong Branch**
Paper/Printing **C & C Offset Printing Co. Ltd.**

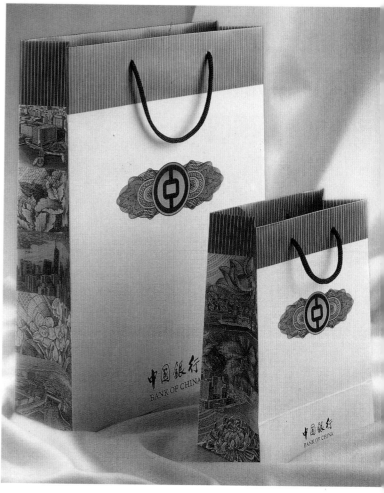

Event

Art Directors/Designers
Lars Busekist, Vibeke Nodskov
Project
Dracula
Client
Dansministeriet, Sweden
Purpose or Occasion
Poster for a modern performance of Dracula
Software
Adobe Photoshop, QuarkXPress
Hardware
Macintosh 800 Quadra

The poster consists of three elements — a photo of an eye, a full moon, and a hand-drawn human figure. The elements were reconfigured using Adobe Photoshop so that the moon became the eyeball and the figure became the pupil of the eye. The new composition was then bitmapped using a diffusion dither.

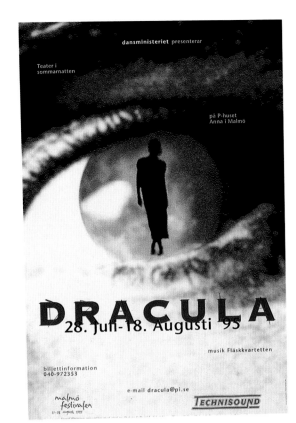

Event

Design Firm
Marketing and Communication Strategies, Inc.
Art Director
Lloyd Keels
Designer/Illustrator
Eric Dean Freese
Project
Milestones Trade show booth
Client
Milestones Adult Day Health Center
Purpose or Occasion
Booth for upcoming trade show
Software
Adobe Photoshop, Adobe Illustrator, QuarkXPress
Hardware
Power Macintosh 8100/80, Arcus II scanner

Milestones is an adult day health center that stresses education, humanities, and health care within a pleasant environment. The redesign of the Milestones booth included a "Our Loved Ones are Treasures" theme. Utilizing the existing backdrop, one 56" x 80" and three 28" x 40" photographic illustrations were created, each incorporating treasure map imagery. Additionally, a treasure-chest and red "x marks the spot" are used with the booth.

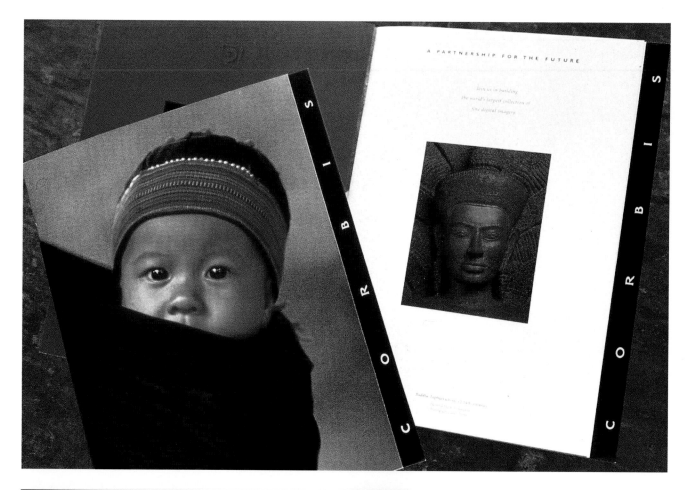

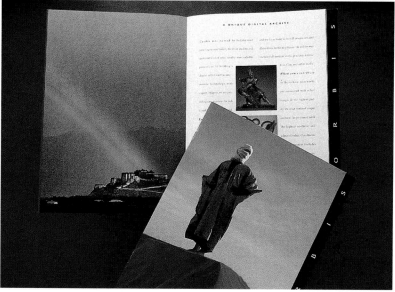

Design Firm **Hornall Anderson Design Works**
Art Director **Jack Anderson**
Designers **Jack Anderson, John Anicker, David Bates, Margaret Long**
Illustrator **Corbis archive**
Client **Corbis Corporation**
Purpose or Occasion **Promotional brochures for services**
Paper/Printing **Vintage Velvet**

The objective was to create two brochures, serving the same purpose, but for different target audiences. One brochure targeted fine-art institutions and the other targeted photographers. Corbis used the brochures to target specific sources to the benefits of archiving their images under the Corbis umbrella. These brochures were designed using QuarkXPress.

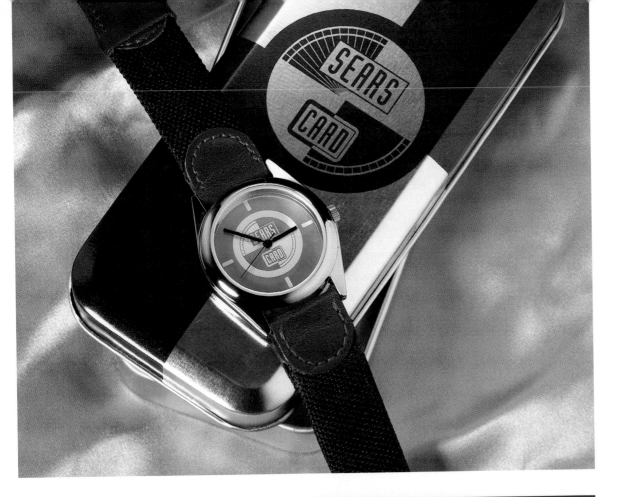

Design Firm
Jim Lange Design
Art Director
Genji Leclair
Designer/Illustrator
Jim Lange
Client
Sears
Product
Watch
Technique
**Watch face and tin art created
in Adobe Illustrator**

This art was created on disk for a promotional watch, tin package, and insert card announcing the new Sears credit card design and promotional push.

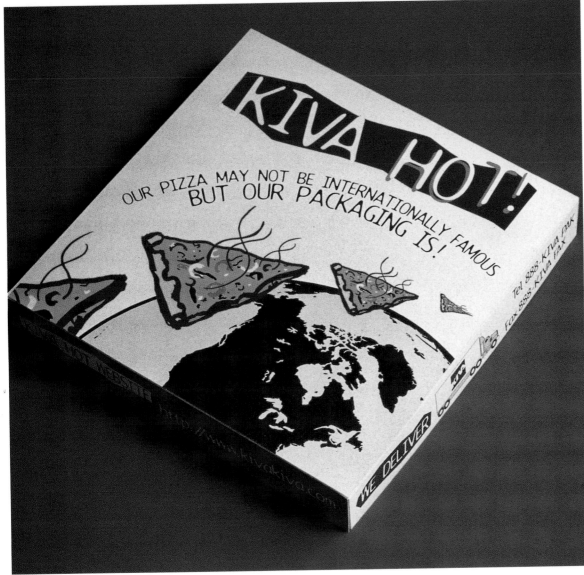

Design Firm
**Tieken Design and Creative
Services**
Art Director
Fred E. Tieken
Designer
Rik Boberg, Fred E. Tieken
Client
Kiva International
Product
Promotional pizza box

Pizza slices soar above the earth, tying the graphics to the message, "Kiva customers are the best customers in the world." Sides were used as low-key mini-ads about Kiva International's service. Flying pizza slices were created in Adobe Illustrator and imported into QuarkXPress, then silk-screened on corrugated fiber pizza boxes.

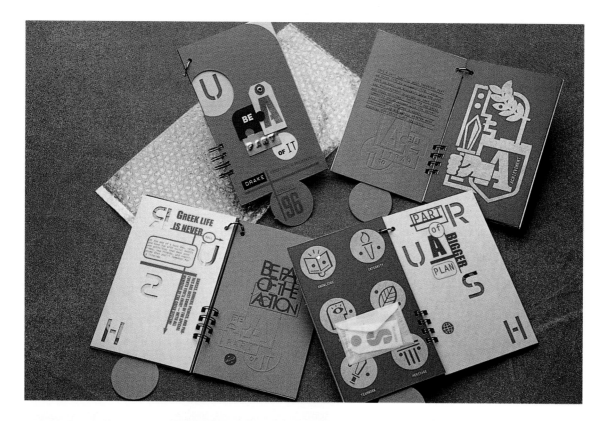

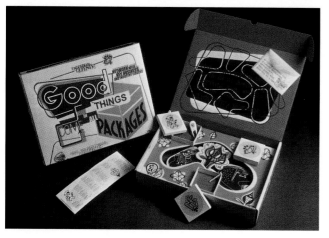

Δ
Design Firm **Sayles Graphic Design**
Art Director **John Sayles**
Designers **John Sayles, Jennifer Elliott**
Illustrator **John Sayles**
Client **Drake University**
Purpose or Occasion **Recruitment brochure**
Paper/Printing **Curtis Retreeve Eggplant, Seamist, Cinnabark, chipboard, manila tag/Offset, Action Print; screen-print, Image Maker; thermography, Parrot Printing**
Number of Colors **Three**

Using the theme "Be A Part of It," the brochure's double-ply chipboard cover is die-cut in the shape of a puzzle piece. Affixed to the chipboard are imprinted "parts"—hammered aluminum, label stock, and manila tags—each bearing a word of the brochure's title. Inside the brochure, a variety of printing and finishing techniques are used for graphics and copy, including thermography, embossing, die-cutting, and offset printing. Hand-applied glassine envelopes contain additional information. The brochure is bound with wire-O binding and an aluminum ring.

Δ
Design Firm **Sayles Graphic Design**
All Design **John Sayles**
Client **Iowa Open**
Purpose or Occasion **Golf-tournament sponsor invitation**
Paper/Printing **Hopper Hots, corrogated board/Offset, Screen-print, Image Maker**
Number of Colors **Four**

Sayles Graphic Design has created a unique direct mailing targeting prospective sponsors of the 1995 Iowa Open golf tournament. Local business leaders received a large corrugated box printed with bold graphics proclaiming the benefits of sponsoring the Iowa Open. Inside is a shadowbox scene cut from corrugated showing a golfer on a green. Small boxes labeled with the name of each sponsor package—Championship, Eagle, and Birdie—contain a printed list of benefits and a small gift: a tee, a divot tool, and a ball marker. "These boxes were sent to business leaders—people who generally have secretaries who screen their mail. This mailing looks like a gift, so it is more likely to get into the decision-maker's hands and be read," Sayles says.

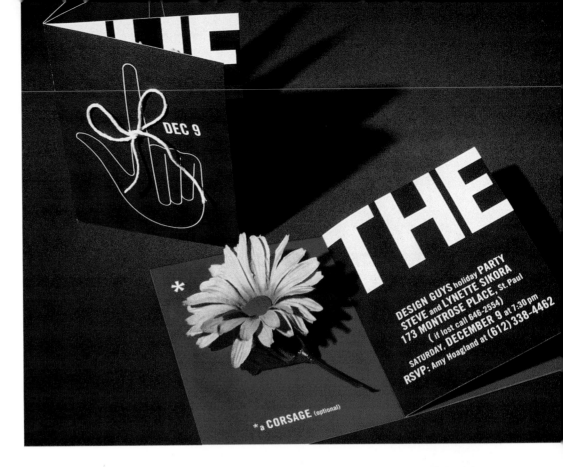

Design Firm
Design Guys
Art Directors
Steven and Lynette Sikora
Designer
Richard Boynton
Client
Design Guys
Purpose or Occasion
Holiday party invitation
Paper/Printing
Cougar opaque
Number of Colors
Two

The designers discovered that it was not easy to be the designer and the client during the production of this invitation. Despite the missed deadlines and the small budget, the end result was well received.

Design Firm
Design Guys
Art Director
Steven Sikora
Designer
Amy Kirkpatrick
Photographer
Darrell Eager
Client
Target
Purpose or Occasion
Wellness Expo Gala
Paper/Printing
**Vintage in various weights/
Scored and die cut**
Number of Colors
Five

This remarkable invitation arrives as a box and when the lid is removed, it opens into a flower. The flower is a symbol of wellness and was used as an icon for the event.

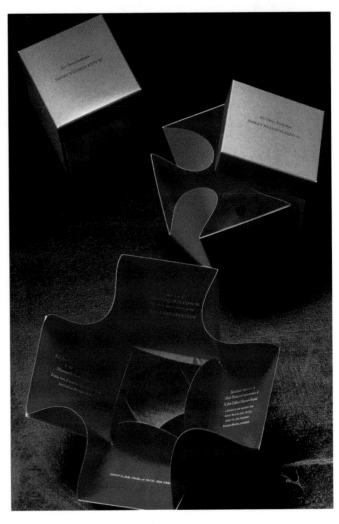

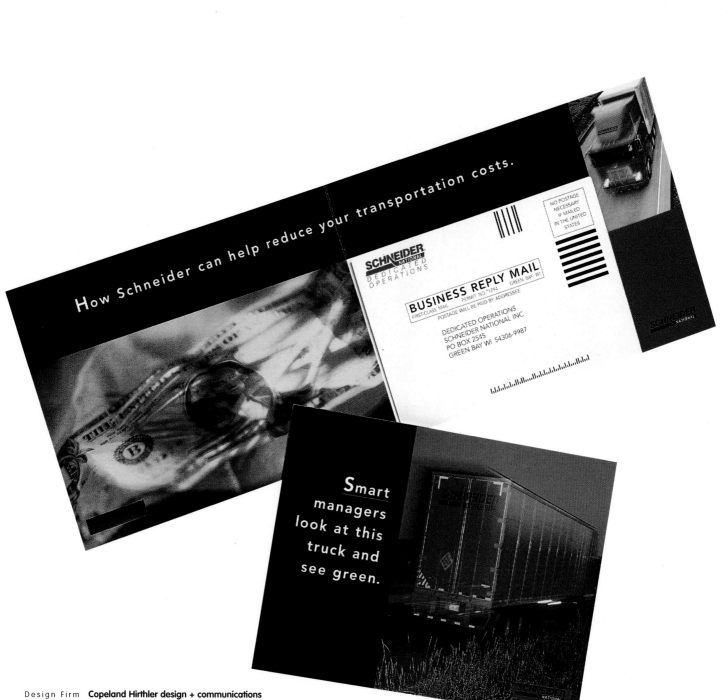

How Schneider can help reduce your transportation costs.

NO POSTAGE
NECESSARY
IF MAILED
IN THE UNITED
STATES

SCHNEIDER
NATIONAL
DEDICATED
OPERATIONS

BUSINESS REPLY MAIL
FIRST-CLASS MAIL PERMIT NO. 1794 GREEN BAY WI
POSTAGE WILL BE PAID BY ADDRESSEE

DEDICATED OPERATIONS
SCHNEIDER NATIONAL INC
PO BOX 2545
GREEN BAY WI 54306-9987

Smart managers look at this truck and see green.

Design Firm **Copeland Hirthler design + communications**
Creative Directors **Brad Copeland, George Hirthler**
Art Director **Melanie Bass Pollard**
Designers **Melanie Bass Pollard, Shawn Brasfield, Lea Nichols**
Copywriters **Melissa James Kemmerly**
Photographer **John Grover**
Client **Equifax**
Purpose or Occasion **Direct mail incentive**
Paper/Printing **Starwhite Vicksburg, French Durotone, GilClear**
Number of Colors **Four plus two spot**

This direct-mail campaign was created to improve product awareness
inside the retail and banking industry and increase the perception that
Equifax is a leader in strategic information related services. Keys were
used as a visual metaphor to relate the product benefits and continued
to serve as a major design element throughout collateral materials. The
project had three direct mail pieces: a teaser, an informational sheet,
and a substantial informative package that included a premium leather
embossed key-ring. By shooting photography separately and then creat-
ing montages in Adobe Photoshop, Adobe Illustrator, and QuarkXPress,
the designers were able to build up an extensive library of photography
for the client's use in all later projects.

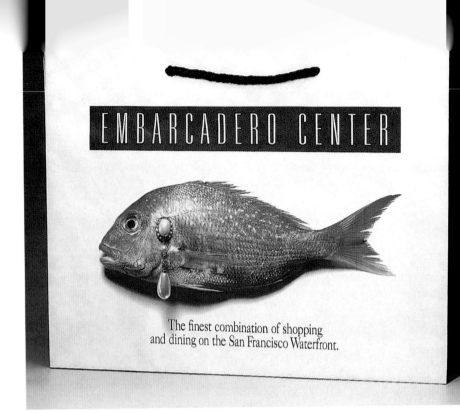

The finest combination of shopping
and dining on the San Francisco Waterfront.

Client/Store
Embarcadero Center
Bag Manufacturer
**Keenpac North
America Ltd.**
Distributor
Conifer-Crent Co.

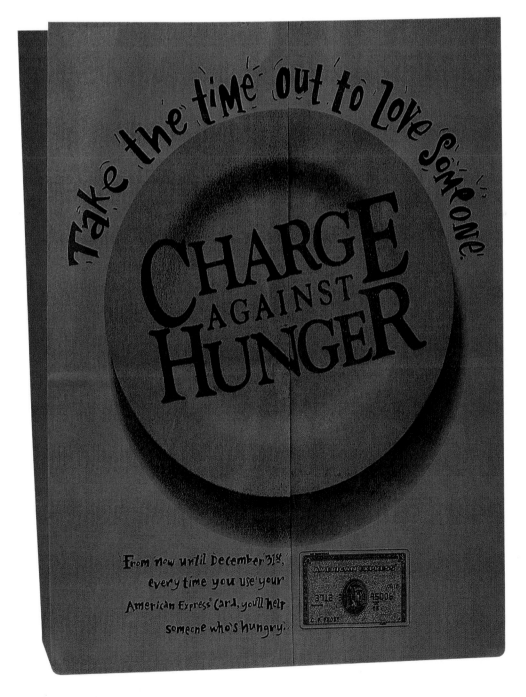

Design Firm
**Enterprise/
Ogilvy & Mather**
Client/Store
American Express
Bag Manufacturer
**ModernArts production
facility, United States**
Paper/Printing
**Printed black on natural
kraft paper**

The bag was used in the
"Charge Against Hunger"
campaign by American
Express. It was inserted in
the L.A. Times and the New
York Times.

Design Firm **North American Packaging Corp.**
Art Director **John DeStefano**
Designer **John DeStefano**
Bag Manufacturer **North American Packaging Corp.**
Paper/Printing **Natural kraft**

Conceived for promotional use, the accordion bag later was considered for its space-saving ability, so much that North American applied for patents.

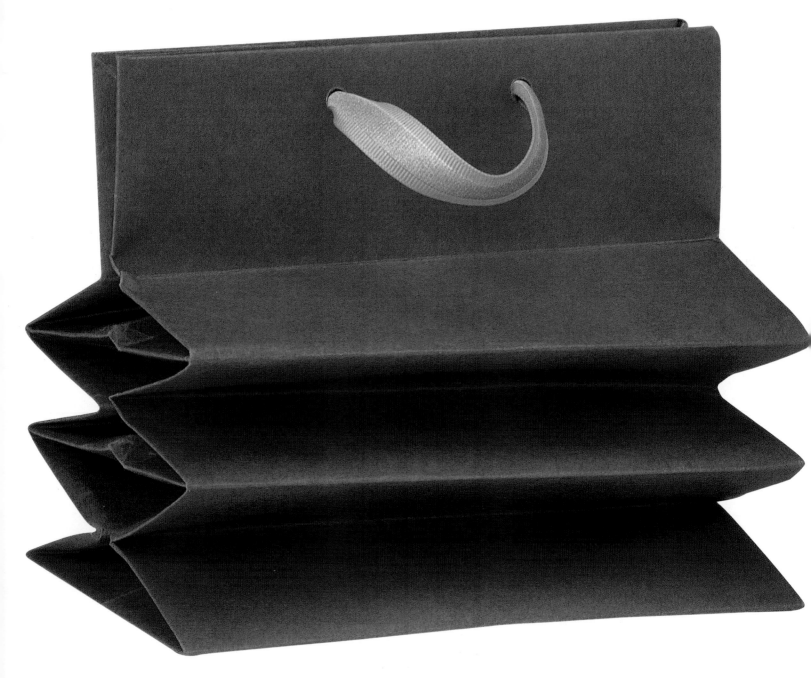

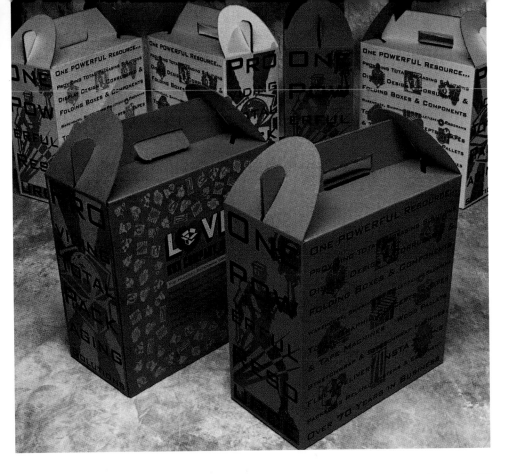

Design Firm **Love Packaging Group**
All Design **Tracy Holdeman**
Client **Love Box Company**
Product **Trade show carry-all box**
Technique **Flexography on corrugated board**

Because Love Box Co. is a corrugated box manufacturer, it designed the box to be printed flexographically with three colors on corrugated board. The design was created by hand except the type, which was set in Macromedia FreeHand and output on a 600 dpi laser printer. The colors were chosen so that they would work when overprinted and therefore involve no trapping.

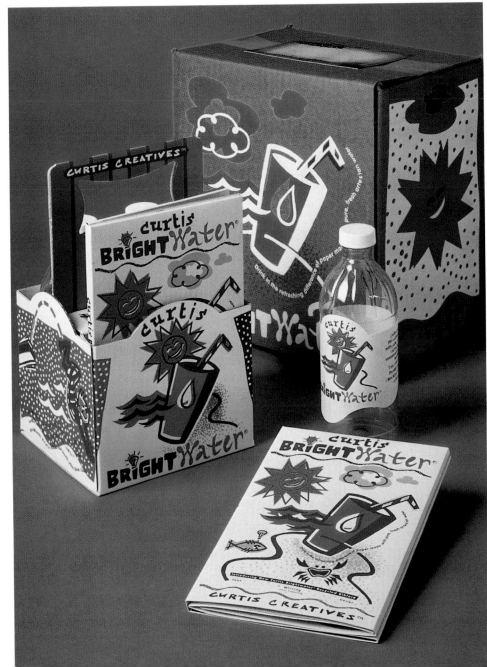

Design Firm **Sayles Graphic Design**
All Design **John Sayles**
Client **James River Paper Corporation**
Product **Curtis Brightwater**
Technique **Offset, screen**

Curtis Brightwater papers were introduced with a splash. John Sayles developed a unique presentation inspired by the product's name—bottles of "brightwater" accompany swatch books in a beverage carrier.

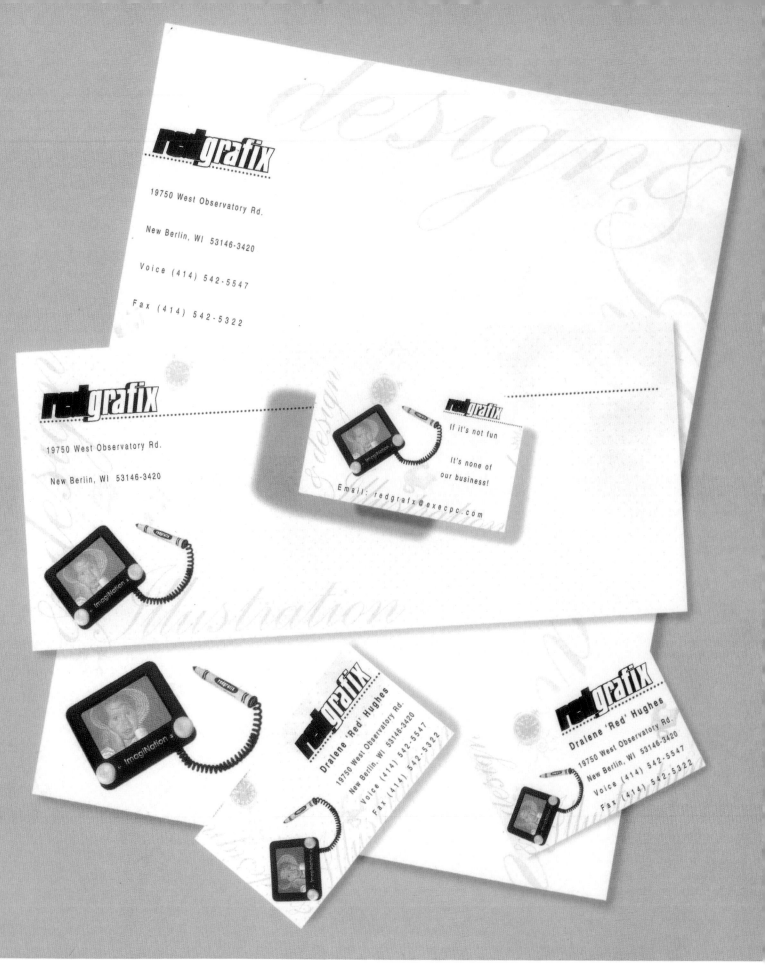

Design Firm **Redgrafix Design & Illustration**
All Design **Dralene "Red" Hughes**
Client **Redgrafix Design & Illustration**
Tools **Adobe Photoshop, Adobe Illustrator, QuarkXPress**
Paper/Printing **Strathmore Elements White/Four color, TI Printing**

not just exhibits

Design Firm **Tanagram**
Art Director **Eric Wagner**
Designer/Illustrator **Eric Wagner, David Kaplan, Erik DeBat**
Copywriter **Lisa Brenner**
Client **MG Design**
Tools **Adobe Photoshop, Macromedia FreeHand, Strata, QuarkXPress**
Paper/Printing **Howard Antique Parchment, Productolith/Consolidated Printing**

This brochure illustrates the uniquely expansive range of services that MG Design, an exhibit design company, offers to its clients. The piece is digitally illustrated and the client's corporate colors were substituted for process colors on press.

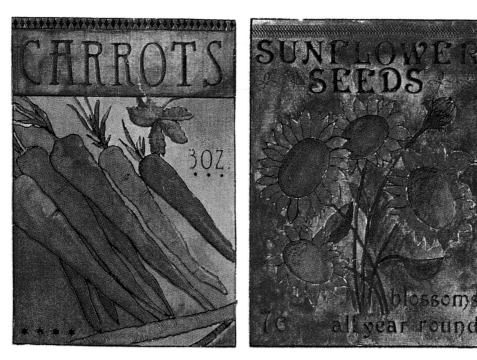

Design Firm **Red Bee Studio**
Designer/Illustrator **Carole Marithe Marchese**
Client **Red Bee Studio**
Product **Seed packets**
Technique **Gouache paintings**

These seed packages were inspired by old-time fruit and vegetable labels. They were designed purely for promotional pieces and have inspired many products including T-shirts and fabric.

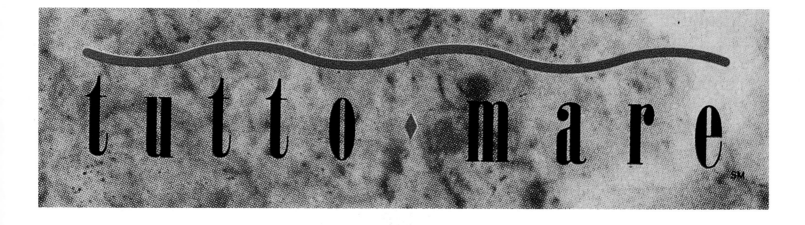

Design Firm **Primo Angeli Inc.**
Art Director **Primo Angeli**
Designer **Primo Angeli, Chip Toll, Judy Radiche**
Client **Spectrum Foods**
Product **Restaurant matchbox**

This tiny matchbox, representing the Tutto Mare brand name of a Spectrum Foods restaurant, is the tip of the iceberg. It conveys a clear sense of the style that was carried throughout the visual system, which relied on a rich mixture of contemporary and traditional appointments.

Event

Design Firm
Copeland Hirthler Design and Communications
Creative Directors
Brad Copeland, George Hirthler
Art Director/2D Designer
Todd Brooks
3D Designers/Illustrators/Photographers
Glenn Gyssler, stock photos
Copywriter
Melissa James Kemmerly
Project
Riverwood Next Wave campaign
Client
Riverwood International
Purpose or Occasion
Employee campaign
Software
Adobe Illustrator, Adobe Photoshop, QuarkXPress
Hardware
Macintosh 8550

The Riverwood Next Wave project was a series of pieces created for an internal employee-awareness campaign.

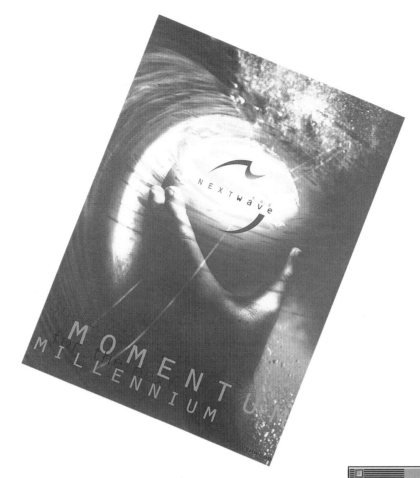

Event

Design Firm
Metropolis Corporation
Creative Director
Denise Davis
Assistant Creative Director
Lisa DiMaio
Illustrator
Karen Ross
Project
ITG Scarves
Client
Booz, Allen and Hamilton, Inc.
Purpose or Occasion
Information Technologies Conference
Software
Adobe Illustrator

Each scarf was made up of extracted mobile images. In their original mobile form, they represent the uniting of complex business and operational activities to provide flexible information for effective decision making.

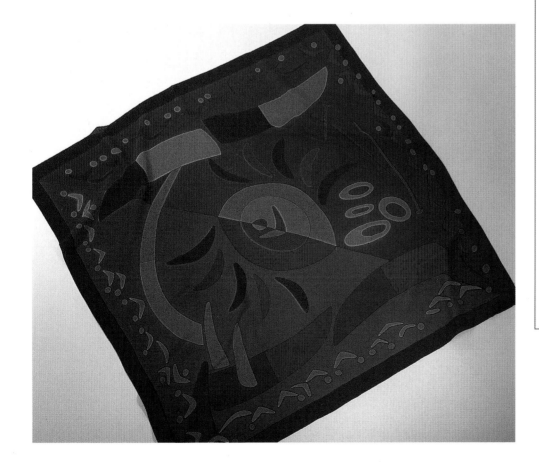

Design Firm
Frank Kunert
All Design
Frank Kunert
Client
Journal Frankfurt
Purpose or Occasion
Dinner for two
Number of Colors
Four

This invitation card visually portrays a first rendezvous: a hide-and-seek, a show, a looking in the mirror, asking, "Am I pretty enough?" "Will they show up, or won't they show up?" "Is he/she the right one?"

Design Firm
Frank Kunert
All Design
Frank Kunert
Client
Frank Kunert
Purpose or Occasion
Invitation for a male event
Number of Colors
Four

The shirt is made of flour and the tie is of real fruits. The light was set up to create a plastic atmosphere. Unfortunately you can't wear these clothes!

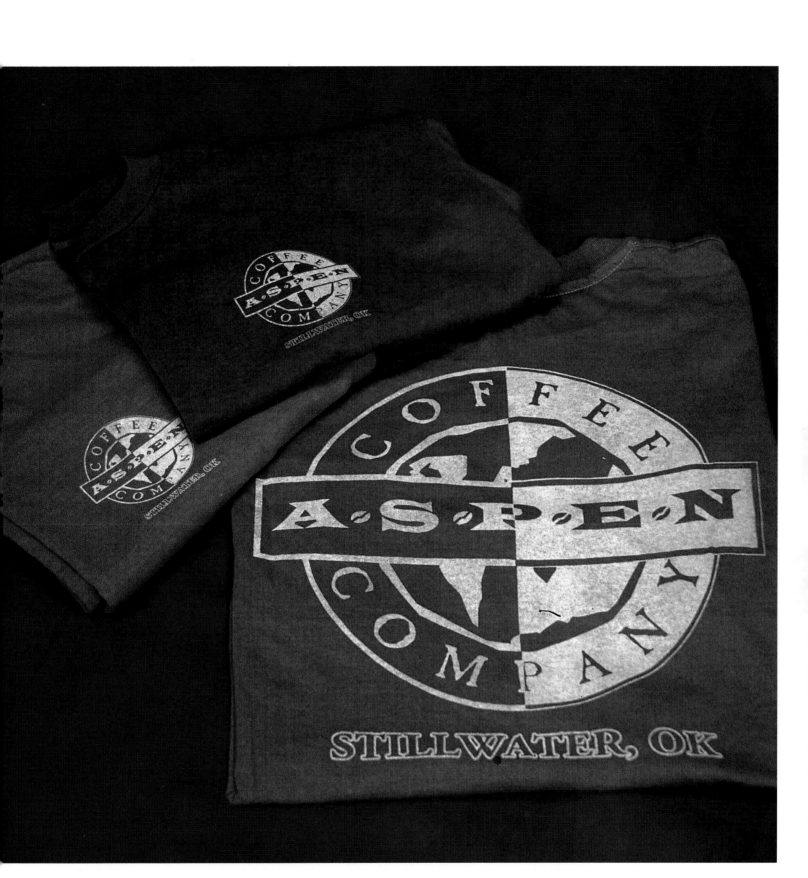

Design Firm **j k design**
Art Director **Kelly Lyda**
Designer **Jeanne Knobbe**
Client **Aspen Coffee Company**
Purpose or Occasion **Promotion**
Number of Colors **One**

The clients wanted a shirt printed with a variation of their logo to be sold in their coffeehouses. This one, with a small imprint on the chest and a large version of the same on the back, has been extremely popular with their customers.

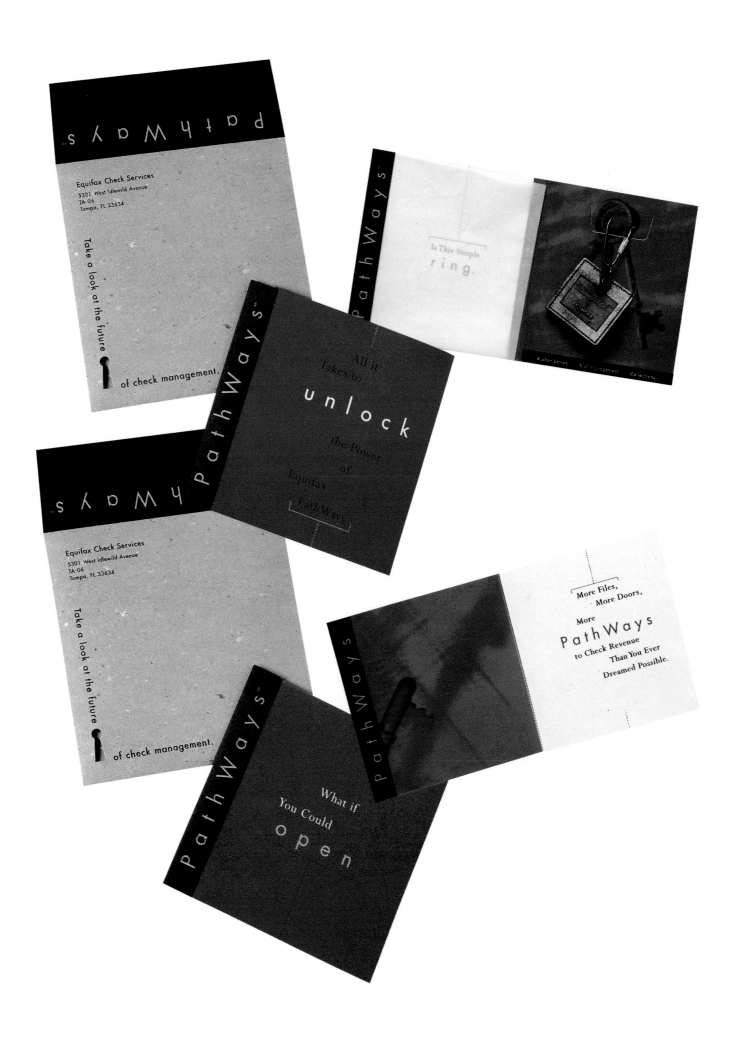

Equifax Check Services
5301 West Idlewild Avenue
TA-06
Tampa, FL 33634

Take a look at the future

of check management.

PathWays

All it
Takes to

unlock

the Power
of
Equifax
PathWays

Is This Simple
ring.

PathWays

Authorization Risk Management Collections

Equifax Check Services
5301 West Idlewild Avenue
TA-06
Tampa, FL 33634

Take a look at the future

of check management.

PathWays

PathWays

What if
You Could

open

PathWays

More Files,
More Doors,
More
PathWays
to Check Revenue
Than You Ever
Dreamed Possible.

Design Firm **Copeland Hirthler design + communications**
Creative Directors **Brad Copeland, George Hirthler**
Art Director **Melanie Bass Pollard**
Designers **Melanie Bass Pollard, Shawn Brasfield, Lea Nichols**
Copywriters **Melissa James Kemmerly**
Photographer **John Grover**
Client **Equifax**
Purpose or Occasion **Direct mail incentive**
Paper/Printing **Starwhite Vicksburg, French Durotone, GilClear**
Number of Colors **Four plus two spot**

This direct-mail campaign was created to improve product awareness inside the retail and banking industry and increase the perception that Equifax is a leader in strategic information related services. Keys were used as a visual metaphor to relate the product benefits and continued to serve as a major design element throughout collateral materials. The project had three direct mail pieces: a teaser, an informational sheet, and a substantial informative package that included a premium leather embossed key-ring. By shooting photography separately and then creating montages in Adobe Photoshop, Adobe Illustrator, and QuarkXPress, the designers were able to build up an extensive library of photography for the client's use in all later projects.

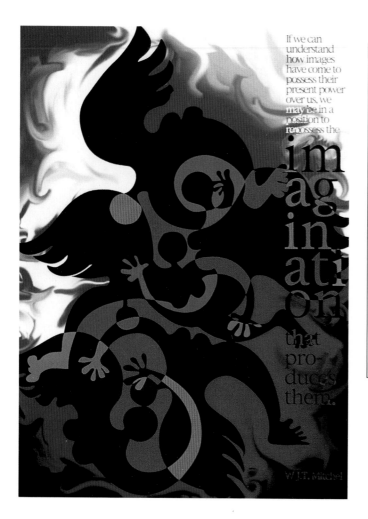

If we can
understand
how images
have come to
possess their
present power
over us, we
may be in a
position to
repossess the
imagination
that pro-
duces
them.

W.J.T. Mitchel

Promotion

Design Firm
Burgeff Co.
All Design
Patrick Burgeff
Project
Presentation
Client
Jan Van Eyck Akademie
Purpose or Occasion
Participants booklet
Software
Macromedia FreeHand, Adobe Photoshop
Hardware
Macintosh Centris 650

The layout for this presentation was transferred to FreeHand and then redrawn with bezier tools and imported into Photoshop. Several channels were created to refine the color of the final piece and the clouds effect was done using the finger tool.

Promotion

Design Firm
Tangram Strategic Design
Creative Director
Enrico Sempi
Art Director/Designer
Enrico Sempi
Illustrator
Guido Rosa
Project
Orologio/Watch
Client
Cesare Fiorucci
Purpose or Occasion
Promotion
Software
Adobe Illustrator, Adobe Photoshop
Hardware
Power Macintosh 9500/200

This watch design incorporates elements of Italy, Italian landscape, and an Italian carnival.

POLAR BEAR PLUNGE · SAN DIEGO ZOO

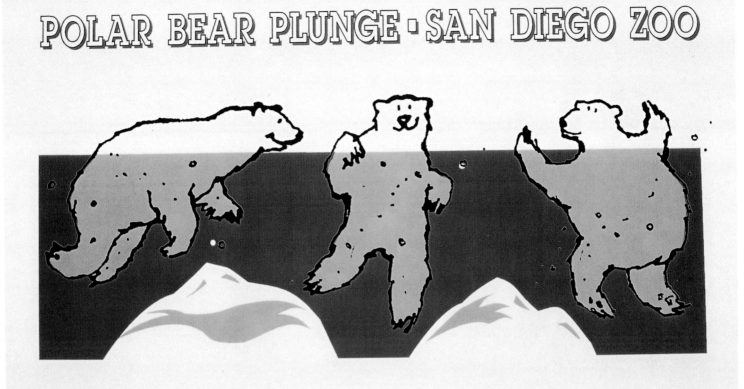

Design Firm Barbara Ferguson Designs
All Design Barbara Ferguson
Client San Diego Zoo
Product Kids' polar bear bucket and cup
Technique Screen

The San Diego Zoo is proud of its new, more natural environment for its polar bear exhibit. The bears seem happy, too. This children's bucket and cup design depicts the playfulness and activity found by all who visited the bears' new home.

Design Firm Barbara Ferguson Designs
All Design Barbara Ferguson
Client San Diego Wild Animal Park
Product Beverage cup
Technique Screen

The client was looking for not only a fun design for both adults and children, but also a design that depicted the unusual alligator in its environment. This reversed-out format has been an extreme success and was later applied to stickers, shirts, patches, and magnets.

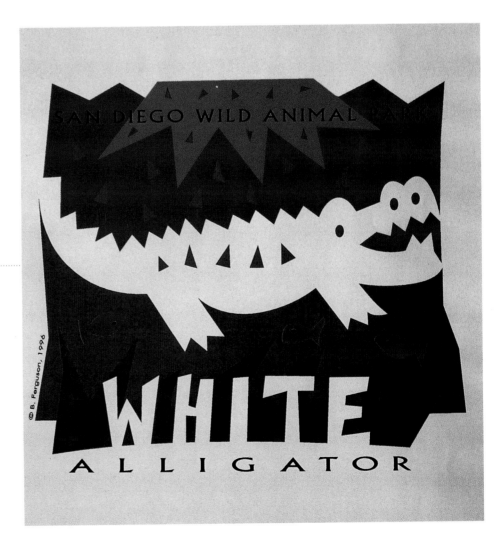

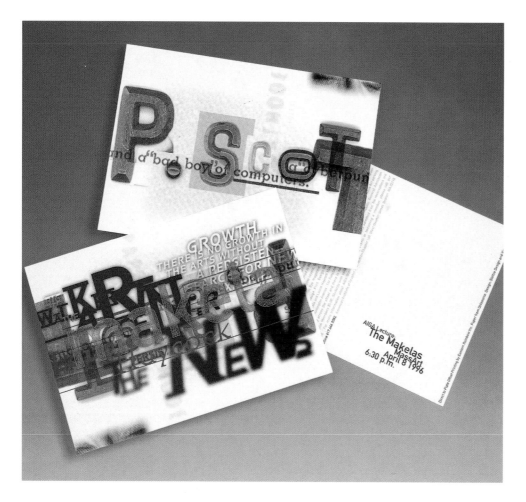

Design Firm
Stoltze Design
Art Director
Clifford Stoltze
Designers
Clifford Stoltze, Fritz Klaetke,
Eric Norman
Client
AIGA, Boston
Purpose or Occasion
Invitation to lecture series
Paper/Printing
Direct to plate offset/silk-screened
overlay
Number of Colors
Four

This was an invitation for a series of lectures sponsored by AIGA, Boston, featuring the extraordinary graphic designers Laurie and P. Scott Makela. The invitations were a series of postcards sent together and printed digitally with the words "The Makelas" silk-screened in gold over the top.

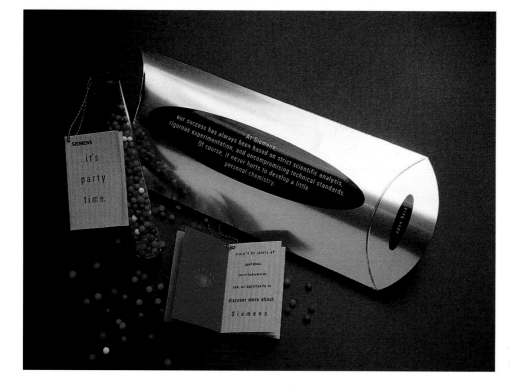

Design Firm
Sibley/Peteet Design
Art Director/Designer
Art Garcia
Client
Siemens Wireless Terminals
Purpose or Occasion
Invitation for customer banquet
Paper/Printing
Columns/Patterson and Company
Number of Colors
Four

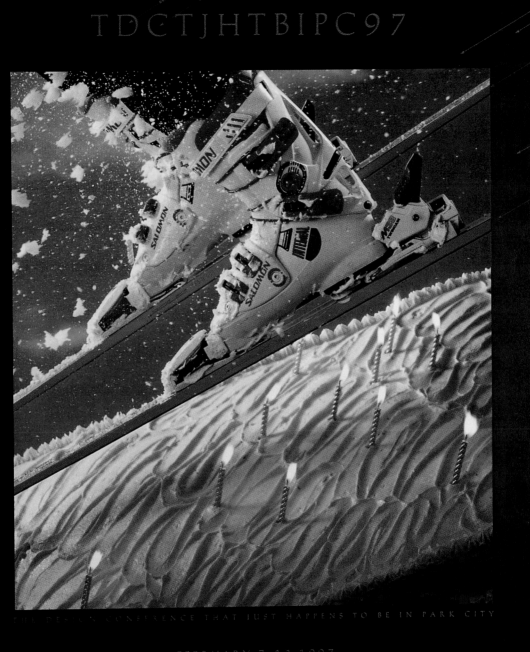

Design Firm **The Weller Institute**
All Design **Don Weller**
Client **The Design Conference**
Purpose or Occasion **Promote design conference at resort**
Paper/Printing **Zellerback/Imperial**
Number of Colors **Five**

The image was planned to suggest the twentieth anniversary of a conference at a ski resort. The photo was slightly retouched using Adobe Photoshop, and the design was created in QuarkXPress. It was printed using dryography.

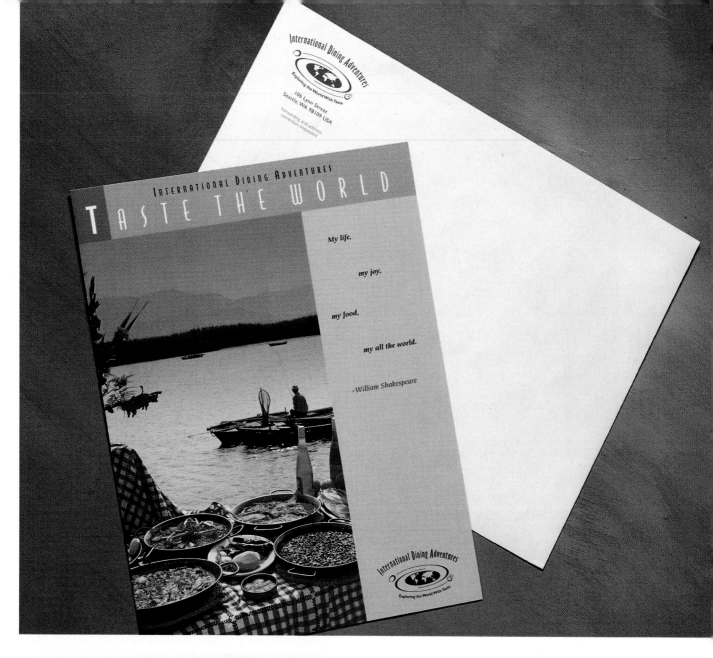

△

Design Firm **Belyea Design Alliance**
Art Director **Patricia Belyea**
Designer **Christian Salas**
Client **International Dining Adventures**
Purpose or Occasion **Tour sales mailer**
Number of Colors **Four**

As the client did not have photographs for all of the proposed destinations, the designers worked with images from international travel commissions. Color corrections and retouching were necessary, as many of the transparencies were yellowed or scratched.

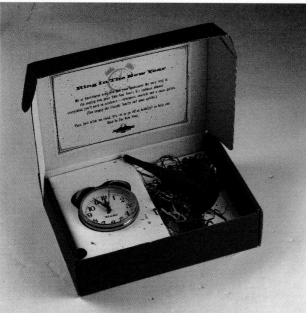

◁

Design Firm **Webster Design Associates, Inc.**
Art Director **Dave Webster**
Designer/Illustrator **Sean Heisler**
Illustrator **Julie Findley**
Client **AmeriServe**
Purpose or Occasion **Promote AmeriServe**
Paper or Printing **Digital**
Number of Colors **Four**

This "timely" holiday promotion helps AmeriServe's clients ring in the new year.

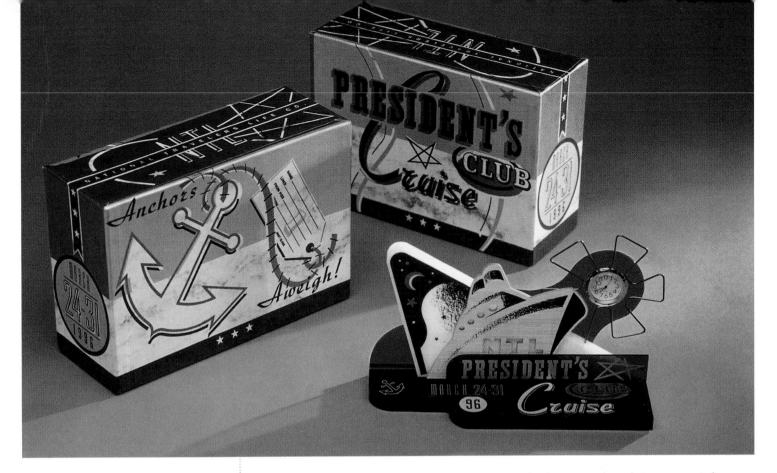

Design Firm **Sayles Graphic Design**
All Design **John Sayles**
Client **National Travelers Life**
Product **President's Club cruise clock**
Technique **Screen**

NTL commissioned Sayles to create a keepsake to commemorate the company's annual cruise for top producers. The small quantity (only 75 were produced) allowed Sayles to develop a spectacular hand-assembled clock made from a variety of materials. Individual pieces of the clock are mounted on a base of dark blue Avonite. Layers of Plexiglas—translucent orange and opaque white—form a horizon behind the aluminum ship, while copper wire creates sun rays around the clock's face. The clock is presented in a box adorned with nautical graphics in copper and blue.

Design Firm **Sayles Graphic Design**
Art Director/Designer **John Sayles**
Illustrator **John Sayles, Jennifer Elliott**
Client **Bally Total Fitness**
Product **Passport to Party promotion**
Technique **Offset**

The fitness company recognizes top performers with a trip outlined in a multipage brochure designed by Sayles Graphic Design. The piece arrives in a graphic, hinge-lid box adorned with screen-printed wood and canvas. The brochure is bound with Kraft raffia. The inside pages are different sizes and colors, printed with visuals that complement the box.

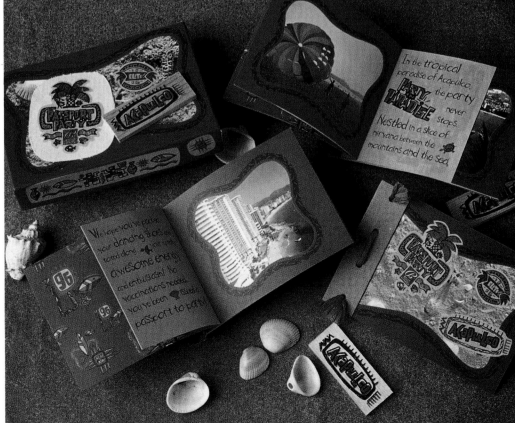

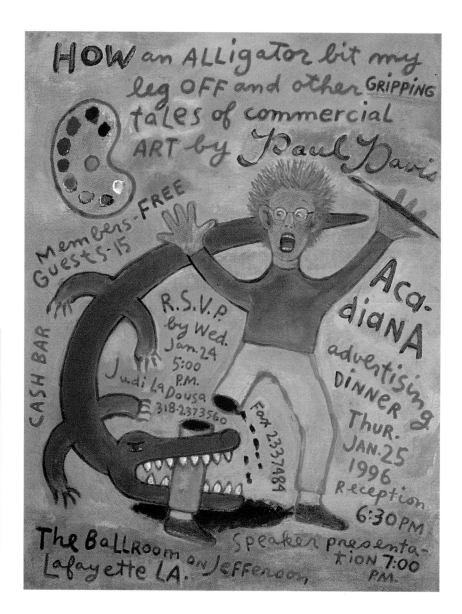

△
Design Firm **Lima Design**
Art Directors/Designers **L. McKenna, M. Kiene**
Client **Northeastern University**
Purpose or Occasion **Campaign dinner**
Paper/Printing **Shawmut Printing**
Number of Colors **Two**

The style of the invitation plays off of the lively logo NU uses for their Centennial Campaign. Special consideration was given to the presentation of this limited budget piece to make the most of the two colors and provide a rich looking piece for the client.

△
Design Firm **Paul Davis Studio**
Designer/Illustrator **Paul Davis**
Client **Acadiana Advertising Federation**
Purpose or Occasion **Dinner**
Number of Colors **Four**

This invitation is for a presentation and lecture given by the artist Paul Davis to an advertising-club dinner. The painting is acrylic on paper.

We're California Dreamin'
and inviting you to a
Sunset Beach Party
on Sunday, July 7th

Wear cool clothes, your shades and
bring your appetite.

Festivities begin at 3:00

Joan and Larry
333 Shore Drive
Laguna Niguel

R.s.v.p. 408-878-2666

No excuses.

Design Firm
American Art Studio
Art Director/Designer
Barbara Biondo
Illustrator
Adam Murguia
Client
Joan and Larry Owen
Purpose or Occasion
Beach party
Paper/Printing
Hand-made paper/Laser-printed insert
Number of Colors
One

The client wanted a totally original concept to announce a beach party. The piece was based on a California casual, "beach-boy" look. Individual sheets of hand-made paper were put through a laser printer and then cut and folded to resemble a shirt. Buttons were chosen to match and a satin ribbon label was applied.

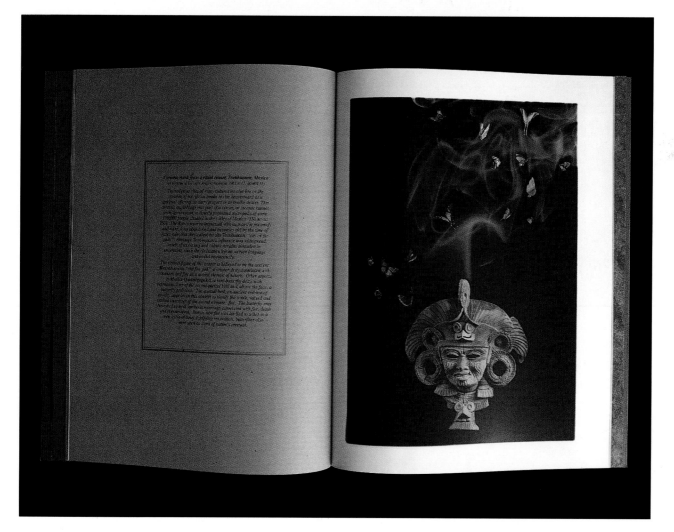

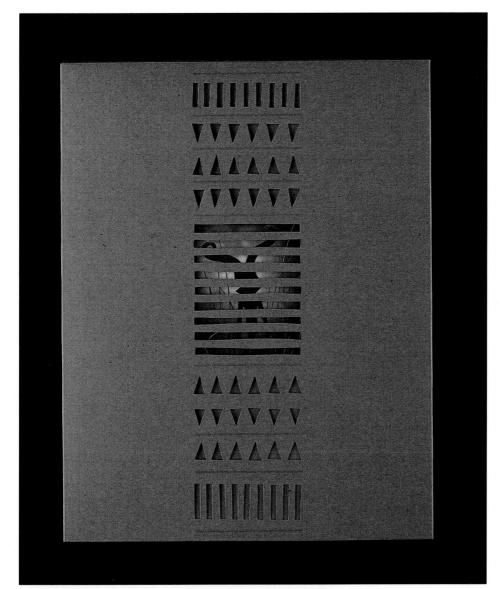

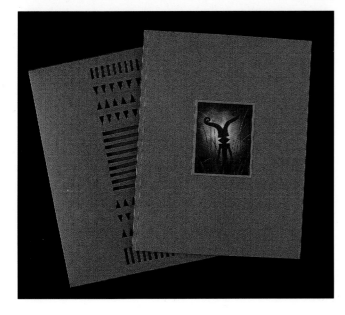

Design Firm **Wood/Brod Design**
Art Director/Designer **Stan Brod**
Photographer **Corson Hirschfeld**
Client **Hennegan Printing Company**
Purpose or Occasion **To promote Hennegan's printing capabilities**
Paper/Printing **Fox River Confetti, Eloquence/Offset geometric screening**
Number of Colors **Six plus heat-foil stamping and die-cutting**

Photos of ancient artifacts from around the world and the unusual environments they are found in are the subject of this promotion piece. Corson Hirschfeld's photographs add a mystical quality to the visuals. The designers used such special techniques as: stochastic printing (geometric screening) for fine reproduction, foil stamping to contrast the ancient environment, and die-cutting to create a primitive-looking pattern for the envelope.

For more work by these designers and others, please
see the following titles, also by Rockport Publishers:

The Best of Brochure Design 4
The Best Direct Response Design
The Best Invitation, Card, and Announcement Design
Digital Design
Great T-Shirt Design #3
Letterhead and Logo Design 5
Package & Label Design
Shopping Bag Design 2